IMAGES
*of America*

# ORLANDO
# FIREFIGHTING

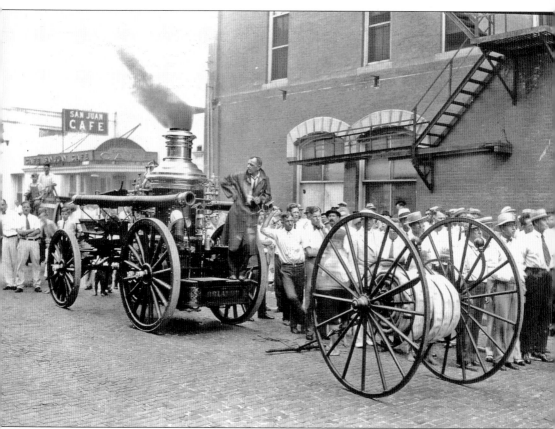

**ON THE COVER:** K. C. Moore stands atop the 1911 steamer during the 1926 Gamewell System dedication. The system utilized a call box on every city corner. When pulled, bumps on code wheels inside the box transmitted the box number to dispatch. Bells, known as gongs, and holes punched in paper tape corresponded to street intersections where the alarm boxes were located in the city grid. (Camnitz Collection.)

IMAGES
*of America*

# ORLANDO
# FIREFIGHTING

Ginger Bryant
with a foreword by Lt. Michael Stallings Jr.

ARCADIA
PUBLISHING

Published by Arcadia Publishing
Charleston SC, Chicago IL, Portsmouth NH, San Francisco CA

Printed in the United States of America

Library of Congress Catalog Card Number: 2007934722

For all general information contact Arcadia Publishing at:
Telephone 843-853-2070
Fax 843-853-0044
E-mail sales@arcadiapublishing.com
For customer service and orders:
Toll-Free 1-888-313-2665

Visit us on the Internet at www.arcadiapublishing.com

*My first trip to a firehouse was initiated by my grandfather, Edmund Clinton Asher, when I was about four years old. Throughout my lifetime, he taught me many things and took me to a variety of places to ensure that I was exposed to unique experiences. Both my mother, Arbadella Asher Bryant, and grandmother, Virginia Morgan Asher, aided in my spiritual growth and never squelched sparks of creativity. They encouraged and understood the value of play and invited me to follow my imagination. This book is dedicated to my family, who has shown me unending love. They are my world.*

# CONTENTS

Acknowledgments     6

Foreword     7

1.    Founding Florida and Its Fire Laddies     9

2.    The Old Fire King     15

3.    Whirligig of Vehicles and Their Homes     25

4.    Practice, Prevention, and Public Relations     49

5.    Mutual Aid     65

6.    Thrill Throwers and Fire Fiends     77

7.    Local Favorites and World-Famous Faces     95

8.    Fallen but Never Far from Mind     109

9.    A New Century of Service     117

Bibliography     127

# ACKNOWLEDGMENTS

While there are many individuals who patiently endured interviews and graciously contributed photographs to this historical compilation, there is one historian who stands out above all others involved with this endeavor: my mentor, Dick Camnitz. Dick tirelessly poured over captions, double checked my facts, educated me in the nuances of apparatus, and challenged everything I put on paper. In the end I walked away with a greater love for fire service and a new friend who coincidentally shares my passion for miniature models. Dick is a living treasure trove of the Orlando Fire Department's history, and his knowledge goes far deeper than anything one will ever encounter on paper. I am deeply indebted to him for the months of care reserved for the inspection of this book and his willingness to fight for perfection.

Additionally, I must thank the many supporters of my project at the Orlando Fire Department: Chief James M. Reynolds, Chief Mark Oakes, Chief Frank Cornier, Comdr. Vicki Robles, Amron Cox, and firefighter Roger Hernandez. A special thank you is extended to my "brother in fire," Lt. Michael Stallings Jr., who not only set the tone for the book by writing its foreword but also opened my eyes to the world of a firefighter while riding with him at Station Two. Plus Stallings did not let me die when I had to rappel from a five-story building during training exercises.

All of the photographs in this book came from archives and private collections that were willing to generously share their pictures. Those who proudly donated their assistance and resources include the Winter Park Fire Department's assistant chief, Patrick J. McCabe; Wenxian Zhang and Gertrude Laframboise at the Rollins College Archives; Eleanor Horst Hubler; Chief Randy Tuten; the State Archives of Florida; and Joseph S. Guernsey. I am also obliged to talented photographers Bob Cross, Shawn Keith, Jim Carchidi, and Ed Read. Above all, I am thankful for friends who did not desert me despite discussions of all things fire-related and teachers who positively shaped my growth throughout life. Most of all, I thank God for family.

# FOREWORD

With the incorporation into a town in the year 1875, Orlando was born with only a population of 85; the main industry was cattle. As the town grew, so did the need for a fire department. Ten years later, the Orlando Fire Department (OFD) was formed. From its inception, the fire department, which first started out with two volunteer companies (Hook and Ladder One and Hose Company One), OFD has grown on the ideas of fire service tradition and the constant progression of this dynamic service.

If you were to look at the makeup of the Orlando Fire Department, you would see an organization that has had only 16 fire chiefs in a 122-year history. During a time in the fire-service history when a majority of the fire departments' main focus is on the ever-growing emergency medical service aspect of the job, OFD keeps its focus solid and true. This organization is a fire department whose traditions, heritage, and training keep this ever-hazardous aspect in clear view. From this understanding, the department absorbs further responsibilities such as EMS, high angle, dive rescue, confined space rescue, trench rescue, hazardous materials, and one of the few fire department–run arson/bomb squads in the nation. The Orlando Fire Department continues to accept new tasks and perfect them through training and education. At the same time, it keeps its history and heritage alive. It is this focus that the members and officers of the Orlando Fire Department strive to keep alive and to pass on to the next generation of firefighters.

From its noble beginnings as an all-volunteer department to the formation of 18 engine companies, 6 tower companies, 8 rescue companies, 1 heavy rescue company, 1 crash/fire company, 4 district chiefs and a division chief, manned by over 600 members and many other support personnel, both civilian and civil service, OFD continues to grow with the ever-demanding needs of the visitors and the citizens of the city of Orlando.

—Lt. Michael Stallings Jr.
The Orlando Fire Department
Founder of the Fraternal Order Of Leatherheads (F.O.O.L.s)

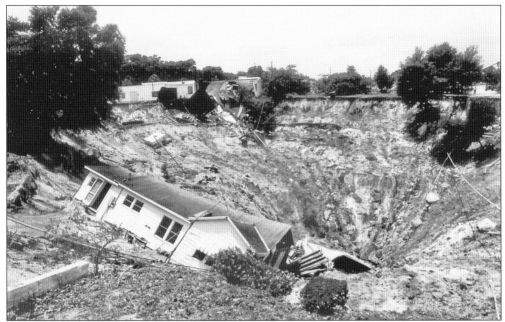

In 1850, Orlando was nothing more than forested expanses of land atop limestone. This soluble rock gives way in the form of sinkholes, leaving behind recesses that collect water and ultimately form lakes. Such unstable pockets of land, as seen in this 1981 sinkhole in Winter Park, often require rescue efforts from the fire department. (Winter Park Fire Department.)

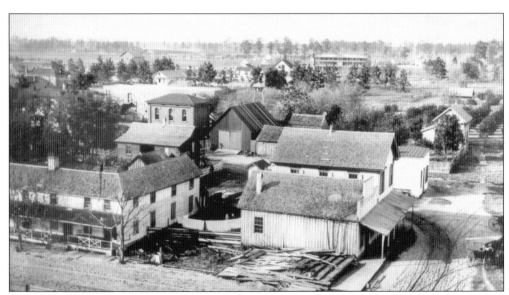

After the completion of city hall (brick building at left in back), the City of Orlando built its first fire station next door in 1885. The tin roof of the engine house, as seen here in the central rear portion of the photograph, was utilized as a drying rack for the fire hoses that were draped in the sun to drain after use. (Chief Randy Tuten Family Collection.)

# One

# FOUNDING FLORIDA AND ITS FIRE LADDIES

Claimed for Spain by Ponce de Leon in 1513, Florida became a land filled with Native Americans and escaped slaves from Georgia by 1763. The 1835 Treaty of Fort Moultrie forced two Native American villages, in an area later named Orlando, to relocate south of the town where lack of game and provisions led to starvation and ultimately the Seminole Wars. To attract more people to Florida, the 1842 Armed Occupation Act provided free land for settlers who agreed to live as citizen-soldiers. It was believed that these new settlers could serve as a barrier against the Native Americans in the area. For this reason, Fort Gatlin was at the center of a settlement that became Orlando. With the intention of luring more settlers, Mosquito County changed its name to Orange County in 1845. This was the same year that Florida was admitted to the Union as a state.

The year 1883 serves as the date of inception for organized firefighting. It was at this time that William C. Sherman left the Boston Fire Department and moved to Florida, where he and J. Walter Hosier started the Orlando volunteer bucket brigade. It was the large fire in Mrs. Bassett's hat and dress shop, and the near loss of her daughter, which caused Sherman to formulate a more organized way of dealing with fires. Along with Sherman, Ben Bartlett, John W. Gettier, J. Walter Hosier, George Macy, and Tom Mann were the first members of the volunteer fire department, which quickly grew to a 12-member unit. Armed only with a wagon pulled by hand, the unit had a painter's ladder to go along with their bucket brigade.

The official beginning of the Orlando Fire Department can be traced back to 1885, when three volunteer companies merged into one authorized department. Between the raging fire of 1884 and the persuasive writings of Mahlon Gore in the *Orange County Reporter*, the city was finally ready for an organized task force for firefighting. William C. Sherman asked the town for a hose wagon, horse, and harness to aid in the more professional endeavor.

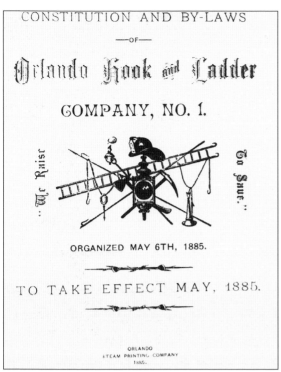

CONSTITUTION AND BY-LAWS

—OF—

Orlando Hook and Ladder

COMPANY, NO. 1.

"We Raise" "To Save."

ORGANIZED MAY 6TH, 1885.

TO TAKE EFFECT MAY, 1885.

ORLANDO
STEAM PRINTING COMPANY
1885.

The Orlando Fire Department's first logo, used May 6, 1885, represented the Orlando Hook and Ladder Company Number One. John W. Weeks served as the first official fire chief for Orlando for three years. Along with N. L. Mills, Weeks arranged for the first agricultural display in Orlando, which evolved into what is now the Central Florida Fair. (Orlando Fire Department Archives.)

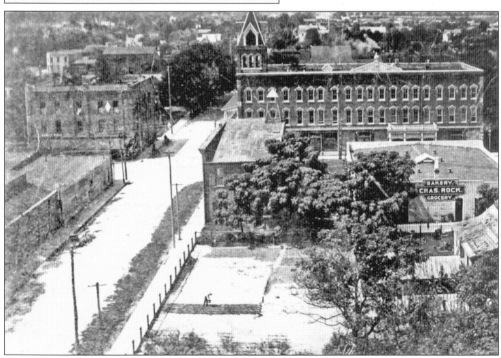

Orange County, which in 1880 contained the future Osceola, Seminole, and Lake Counties, had a population of 6,618. However, in Orlando there were only 200 residents. Downtown Orlando, pictured around 1881, received its first railroad station this year, and the added transportation served as the impetus for growth in the area. (Chief Randy Tuten Family Collection.)

The bell tower at the rear of the 1885 firehouse held the oldest object that the Orlando Fire Department owns today: the fire bell. It was used during the 1926 Gamewell dedication to contrast with the loud alarm of the new system. Though the original firehouse does not exist any longer, the bell resides at present-day Station One. (Camnitz Collection.)

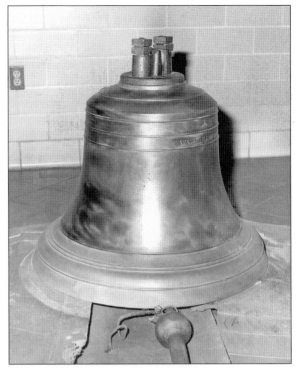

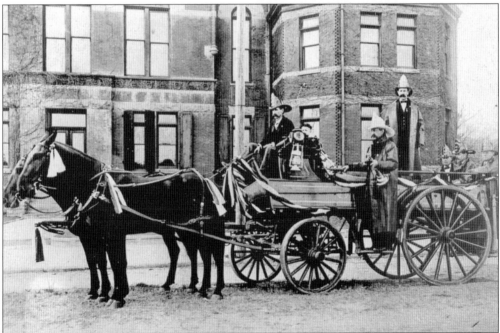

The newest piece of equipment that the fire department owned was showcased in front of the courthouse just after 1892. This apparatus was patterned after a wagon seen in Jacksonville during a competition amongst firefighters. The Orlando firefighters were able to acquire the plans for the wagon and had the apparatus built by a local wagon maker when they returned to town. (Chief Randy Tuten Family Collection.)

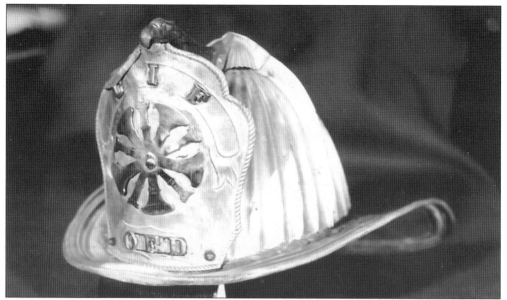

In 1892, the department decided to continue using leather fire helmets despite the fact that a metal helmet, shown here, was sent as a sample to the fire chief in hopes of causing the entire department to convert. Due to a fear of charged wires falling onto a metal helmet, the fire department still uses leather helmets. (Chief Randy Tuten Family Collection.)

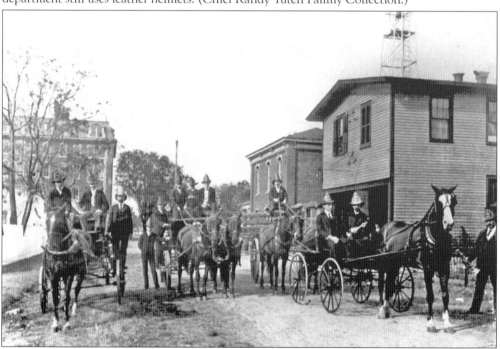

The wooden Oak Street Fire Station and bell tower (right), seen around 1897, were not as ornate as the brick facade of city hall next door. In 1885, the volunteer fire department proposed a $10,000 brick firehouse, which citizens voted down. Due to the big freezes of 1894–1895, a record-breaking low of only 75,000 boxes of oranges could be sent to market, making new construction infeasible. (State Archives of Florida.)

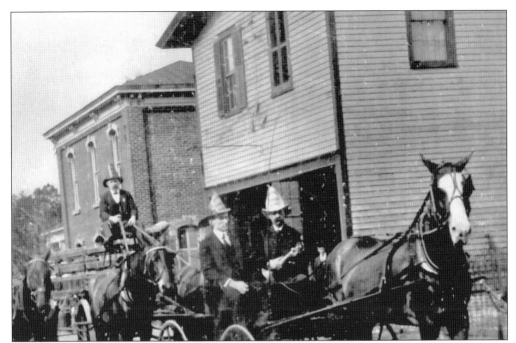

William C. Sherman took the official position of fire chief after John W. Weeks resigned in 1888. Shortly after December 21, 1893, the newly elected and third fire chief, John W. Gettier, changed the title to Chief Engineer of the Fire Department. The Baltimore native resigned in 1896, after this photograph was taken in front of the firehouse. (Chief Randy Tuten Family Collection.)

During the late 1880s, this hose cart was photographed on the trolley tracks of Central Avenue. Orange Avenue is the intersecting street, and the Cheney Building is depicted at left. The reel appears to be decorated with tinsel for the holidays, but such adornment is unexplained. (Orlando Fire Department Archives.)

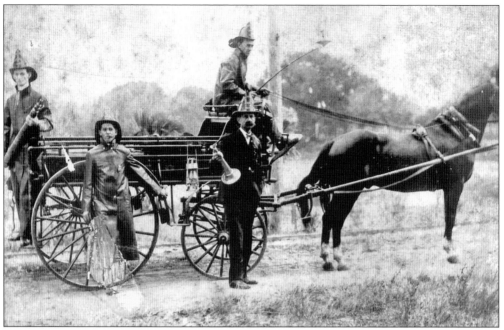

Fire Chief John W. Gettier, with his speaker trumpet in hand, stands with a fire wagon in the 1890s. This trumpet was used for yelling commands to his men during the frenzy of a fire in progress. Gettier was responsible for consolidating all existing companies under the title "Mechanics Hose Company Number One" in 1893. (Chief Randy Tuten Family Collection.)

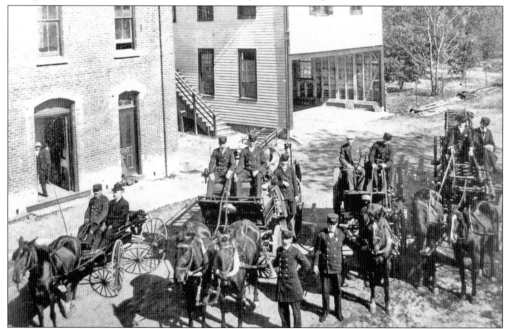

The fourth fire chief, William M. Mathews, can be seen in the horse-drawn carriage (far left) as the passenger on the right. Captured in 1907, this image depicts the volunteer fire department in front of the Oak Street firehouse. The Holland wagon in the center was built in 1897. (State Archives of Florida.)

# Two

# THE OLD FIRE KING

In an article on May 10, 1911, the *Reporter-Star* newspaper aptly dubbed William Dean the "Old Fire King." He was the first paid, longest running, and last elected fire chief. After a total of 48 years in fire service, serving as fire chief intermittently from 1908 until 1936, the mayor and city council gave him the title "Honorary Fire Chief for Life."

Before joining the fire department, William Dean worked in R. L. Hyer's livery stable and then as a fireman for Davis Lockhart at his Orlando Novelty Works. Dean started his career with Mechanics Hose Company Number Two and advanced to the position of plugman before becoming fire chief. Chief Dean was never content with mediocrity and in 1911 was hired by Mayor William Hayden Reynolds as special police for the Opera House. Chief Dean led his men through the Atlantic Coast Line freight depot fire of 1911 and the Wyoming Hotel fire of 1912, which led to the creation of an ordinance prohibiting any person or vehicle from crossing fire hoses when in use.

In the *Evening Reporter Star* newspaper issued on January 28, 1914, Chief Dean was quoted as stating, "Our equipment is inadequate . . . horses are too slow to save a house when the fire is any great distance from the station. I consider a chemical engine one of the greatest needs of the department, for often the water does as much damage as the fire." Chief Dean had recently returned from two venues that were exhibiting the most modern equipment of the era: Jacksonville and the National Firemen's Meet in New York City. Upon returning, the news reporters said he was "as restless as a hyena in a cage," because he wanted to keep the Orlando Fire Department up-to-date as well.

Ultimately Dean was able to witness the transformation from a horse-drawn company to a fully motorized department. In 1923, the entire Orlando Fire Department became a paid department. Dean's role as fire chief began when Orlando was officially nicknamed "the City Beautiful," and that same sentiment was applied toward upgrades for the fire department.

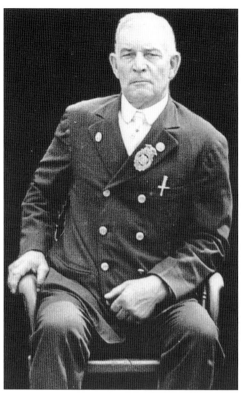

Chief William Dean was vocal prior to the June 8, 1926, election that was held to determine how funds for the city would be spent. In the end, all proposed needs were denied except for the requests for police and fire alarms, an incinerator, and new fire stations. A total of $50,000 was awarded for the construction of two new stations. (Orlando Fire Department Archives.)

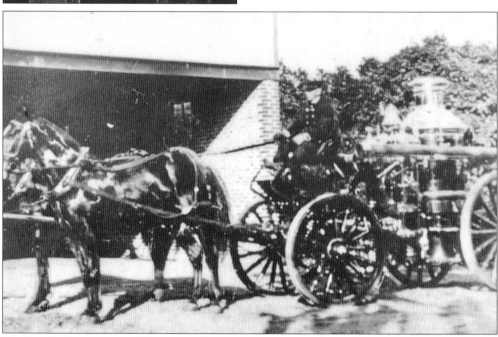

The locally famous team of Fannie and Joe were required to transport the Metropolitan steamer. While this photograph was taken shortly after 1913, city council ordered the new fire engine, which weighed 8,000 pounds, in 1911. Three or four horses were needed to pull it through the sand. (Chief Randy Tuten Family Collection.)

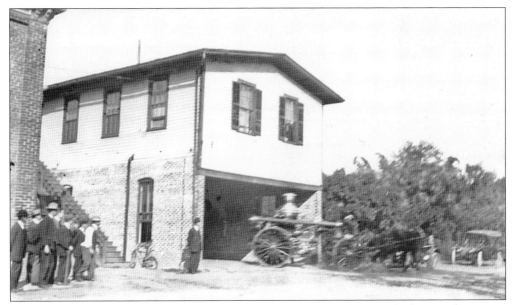

Onlookers in 1913 watch the 1911 steamer pulling out of the Oak Street firehouse. The station was equipped with an apparatus that automatically dropped reins and harnesses from the ceiling so that horses could be tacked quickly. For over 14 years, R. M. Bennett slept at the fire station, hitching horses to wagons before the other volunteers could arrive, especially during night fires. (Orlando Fire Department Archives.)

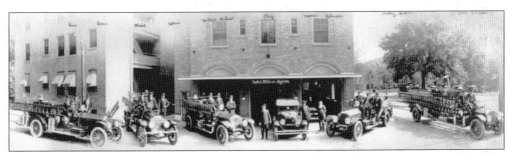

Chief William Dean stands to the left of the chief car, its headlights pointing forward, in the center of the grouping. In 1924, Station One, on North Main Street, displayed its four engines, chief's car, and ladder. The fire department was able to save $40 a month by getting rid of the horses in 1915, after which all vehicles became completely motorized. (Camnitz Collection.)

Around 1920, Chief William Dean acquired Engine Four, a chemical truck. In order to operate a chemical truck, soda and a vat of sulfuric acid were added to an engine's water tank that was three-fourths filled. When cranked, chemicals would mix, creating a reaction that pushed water out of the engine. (Lt. Earl D. Horst Collection.)

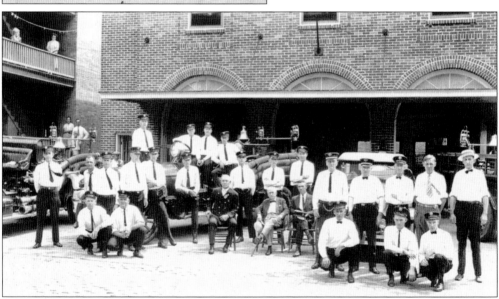

In 1926, the fire personnel gathered outside of Station One for the equivalent of a family portrait. The three men seated in chairs in the center are, (from left to right) Chief William Dean; the second fire chief, William C. Sherman; and the future fire chief, Gideon Dean. Continuing to the right, kneeling, are (left to right) firefighters H. P. Bailey, Ben White, and Wayne Ellis. (Camnitz Collection.)

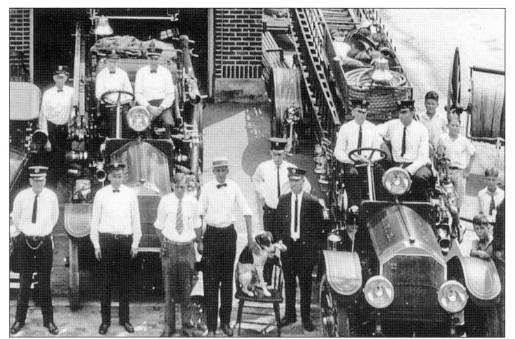

Taking center stage in front of Station One in 1926 was the fire department's dog. Firefighters first got the puppy in 1915, and the November 28 edition of the *Morning Sentinel* newspaper revealed, "The fire laddies are insulted because mention has been made that 'City,' the new dog mascot of the department, is of an unknown breed. His pedigree will arrive this week." (Orlando Fire Department Archives.)

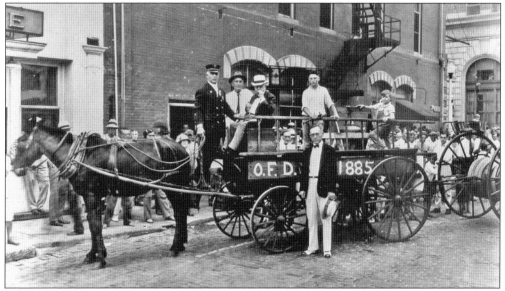

The Gamewell System dedication of 1926 featured the old painter's wagon used by William Sherman's Volunteer Fire Brigade of 1883 in order to represent the beginnings of firefighting in Orlando. Holding the reins is Chief William Dean. Next to Dean, seated in the wagon, are fire buff C. E. Johnson (left) and William C. Sherman. Standing next to the wagon is Mayor L. M. Autry. (Chief Randy Tuten Family Collection.)

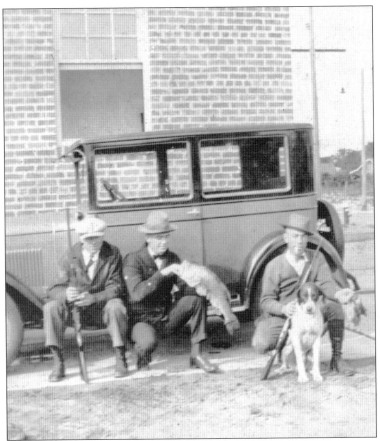

In 1927, (left to right) Claude Morgan, Lieutenant Sanders, and Gideon Dean show off the successful results of their fishing trip while spending time outside Station Four. Though Gideon had to develop his own skills as a firefighter under the scrutiny of his father the fire chief, he too had a love for fire service. (Lt. Earl D. Horst Collection.)

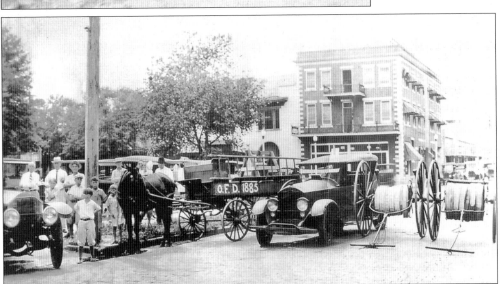

On the day that the Gamewell System was put to use for the first time in 1926, the mayor pulled the alarm at Central and Orange Avenues. Since Chief Dean invited the former chief William Sherman to the event to represent the early days of the department, both companies were involved in the call using historic and modern apparatus. (Chief Randy Tuten Family Collection.)

20

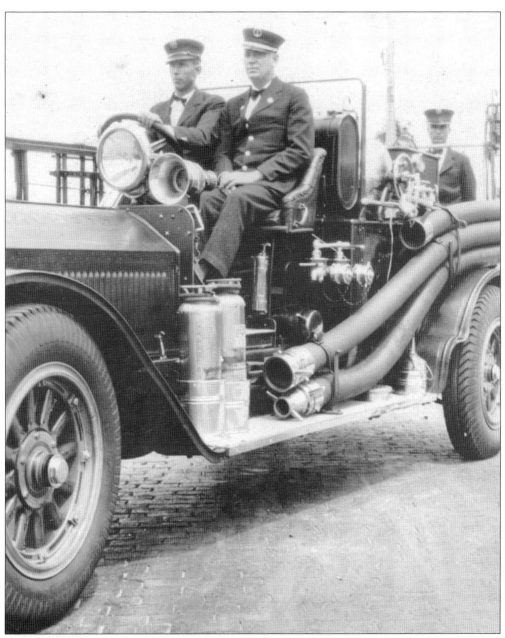

Between 1925 and 1926, Orlando experienced a boom as 3,000 to 5,000 realtors began luring people to the area with promises of cheap, expansive land. Many people came from the North on vacation and decided to remain. Investors began to see through some of the false advertising, and the continuous stream of people from the North began to slow. A renewed interest in Orlando could not be maintained until the area was further developed with railroads, better roads, schools, and businesses. The economy of the area began to stabilize as efforts were put forth by the legitimate investors in the area. By 1927, apparatus was parked outside Station Four during its opening. Fire Station Three opened this same year on the corner of Orlando Street and Dade Street. It was shut down in 1932 and reopened in 1936. By November 5, Mayor Autrey had added two stations in total with all of the necessary equipment. (Lt. Earl D. Horst Collection.)

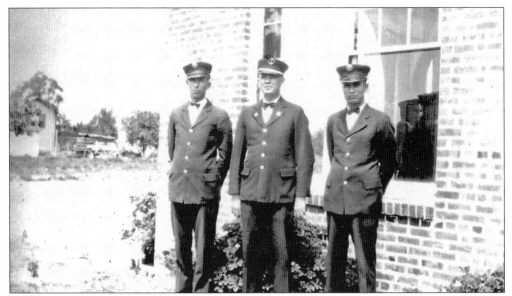

Reveling in the new creation of Station Four in 1927, (left to right) Earl D. Horst, Lieutenant Sanders, and firefighter Al Cox stand next to the brick facade of their new home away from home. Conscious of the fire hazards that wooden structures present, newly built architecture utilized brick for at least the first floor of the building. (Lt. Earl D. Horst Collection.)

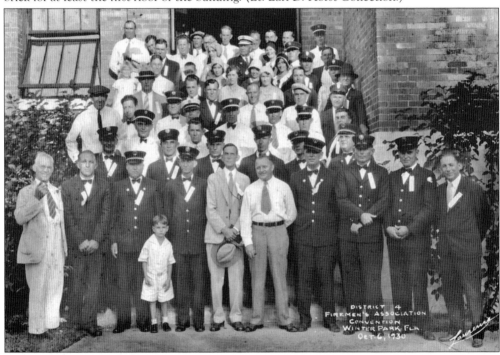

On October 6, 1930, OFD members attended the District Four Firemen's Association Convention in Winter Park, Florida, in order to discuss advancements in the profession. Records of other fire prevention initiatives date back to 1911, when Mayor W. H. Reynolds proclaimed October 8 Fire Prevention Day and ordered townspeople to clean up trash in the area. (Lt. Earl D. Horst Collection.)

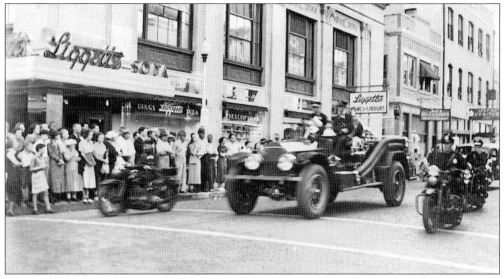

Chief William Dean's funeral services were held on January 24, 1937. In 1936, Dean was forced to retire because of problems with his heart and lungs; however, his legacy will be remembered. Legislation passed during his career gave firemen the status of civil servants in 1935. Dean is remembered as one of the most beloved chiefs the department has known. (Lt. Earl D. Horst Collection.)

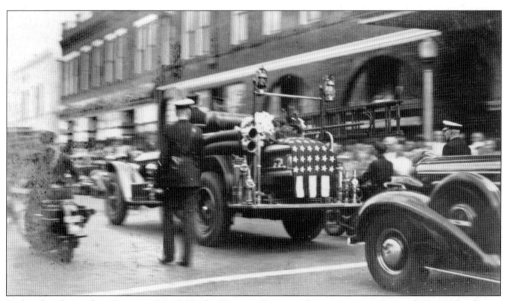

Before his funeral on January 24, 1937, the *Evening Reporter Star* newspaper's April 22, 1915, edition noted, "Chief William Dean has devoted the best years of his life to the fire department in Orlando. . . . He deserves to be pensioned while he lives and canonized when he dies, and no praise is too high for the loyal crew of firefighters he has about him." (Lt. Earl D. Horst Collection.)

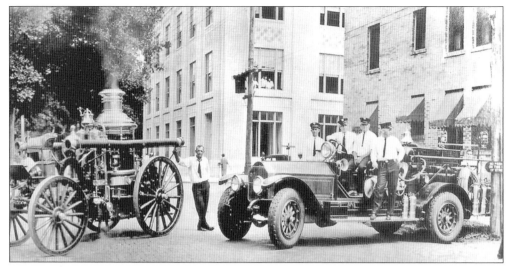

In 1926, the American LaFrance Metropolitan steam-powered fire engine (left) was out on the streets next to Old Number Four (right). Old Number Four was a chemical truck that was later converted to a pumper. This was the apparatus that firefighter Roger "Deke" Coram was riding in when he lost his life in 1944. (Chief Randy Tuten Family Collection.)

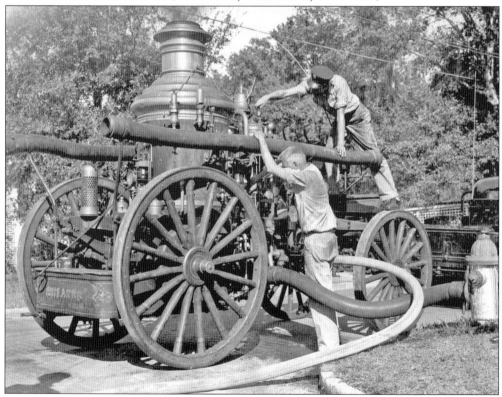

Willie Flick works on the 1911 steamer around 1947 in order to get it fully functioning once again. The steamer was constructed from nickel-plated brass and utilized kerosene lanterns to light up any scene. These lanterns were also used much like taillights on vehicles today. (Lt. Earl D. Horst Collection.)

# *Three*

# WHIRLIGIG OF VEHICLES AND THEIR HOMES

In the June 1, 1915, edition of the *Evening Reporter Star* newspaper, a new fire alarm system was announced, boasting that it would assist fire trucks so that they would no longer have to drive in circles trying to find a fire like a "whirligig of vehicles." In the era of motorized transportation, new inventions designed to aid in firefighting were released at a rapid rate. In 1912, there was the public introduction of a fire bucket tank. This device contained nesting buckets that could be filled with water several at a time, enabling the bucket brigades to gain more speed. With patented, self-raising handles, firefighters could also withdraw buckets filled with chemical solutions. Once this was announced, a large dry goods company had 32 of the tanks installed as a precautionary method for dealing with fire. On April 13, 1915, the proclamation of a basic attachment designed to hook onto elevators so that heavy hoses could quickly be transported to any floor of a high building was newsworthy.

As more apparatus was acquired, homes for its storage had to be provided. The city's first station was somewhat cramped in 1885, providing only enough space for fire apparatus at its house. Therefore additional meeting rooms for the firefighters were rented at the Chaney Building, located at the corner of Orange Avenue and Central Avenue. The firehouse's signature architectural feature was a small wooden bell tower. Whenever a fire was detected, it was up to bystanders to ring the bell, thereby signaling all volunteers to hurry to the firehouse and board apparatus. Such a proposition was daunting, especially since there were only two sources of water: one well on Pine Street and a second at the courthouse on Central Avenue.

While close quarters were an issue for Station One at its inception, it would lovingly be known as "the Big House." With its spacious bays, heavy rescue, confined spaces rescue team, dive team, hazmat services, and other equipment, there were many amenities. But even the Big House, built in 1960, has outgrown its quarters.

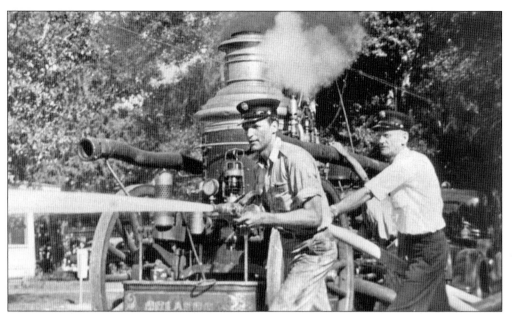

This photograph, taken in the late 1940s, depicts the last time that the 1911 steamer was ever pumped. The steamer, being utilized here by firefighters Larry Camnitz (left) and Hugh Minick, was rebuilt in the 1960s, but the fire chief did not want to fire it up again because the heat produced by the boiler would ruin its finish. (Chief Randy Tuten Family Collection.)

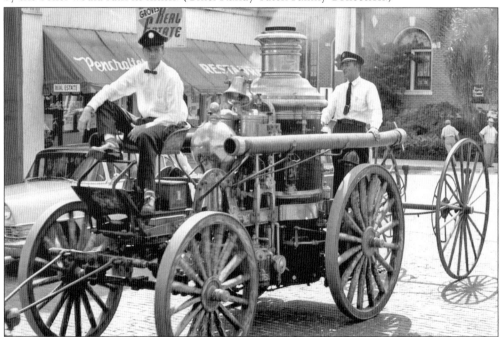

Orlando firefighters parade the Metropolitan steamer through the streets of downtown Orlando around 1955. The metal bulb behind the driver's seat serves as its air chamber. In 1957, firefighters considered pumping two lines of water with this historic apparatus to see which group of men could move a giant ball across Lake Eola first as a part of Orlando's centenary celebration. (Camnitz Collection.)

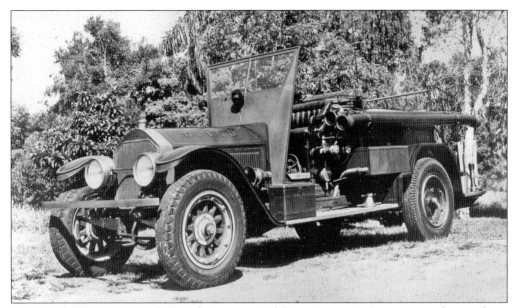

Old Number Five, pictured around 1940, arrived from American LaFrance without a front windshield. After studying the type of shield needed, as it appeared on a nearly identical apparatus, mechanic Willie Flick of the Orlando Fire Department was able to make a perfectly fitted windshield for the Old Number Five. (Chief Randy Tuten Family Collection.)

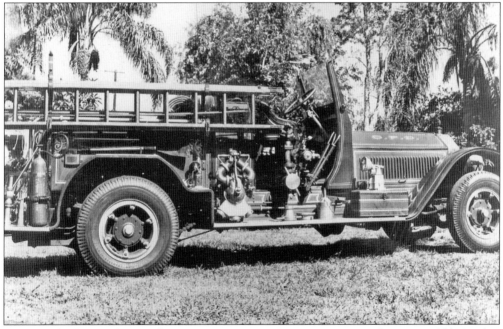

Photographed around 1940, this 1926 American LaFrance engine was known as Old Number Six. It was purchased by Chief William Dean and was later restored in the 1960s by Orlando Fire Department mechanic Willie Flick. Today the apparatus resides in the Orlando Fire Museum as a part of the timeline of fire service. (Chief Randy Tuten Family Collection.)

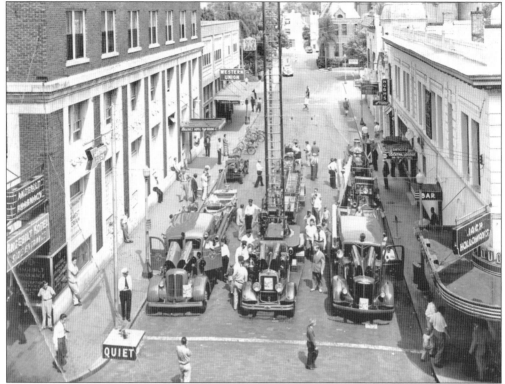

In 1946, a fire prevention display was lined up on the corner of Orange Avenue and Wall Street. The apparatus included, from left to right, a 1942 Seagrave pumper, 1936 American LaFrance tiller aerial ladder, and a 1946 Mack pumper. The two outside trucks do not have chrome because they were purchased during World War II, when the use of chrome was kept to a minimum. (Camnitz Collection.)

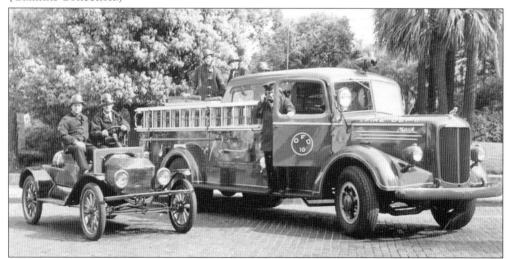

From left to right, Mack Brinkley, Paul Pennington, and Dennis Pennington display apparatus, including Old Number Ten, in October 1946. The Model T (left) was loaned to the Orlando Fire Department display as a part of Fire Prevention Week festivities and was not used by the department. (Lt. Earl D. Horst Collection.)

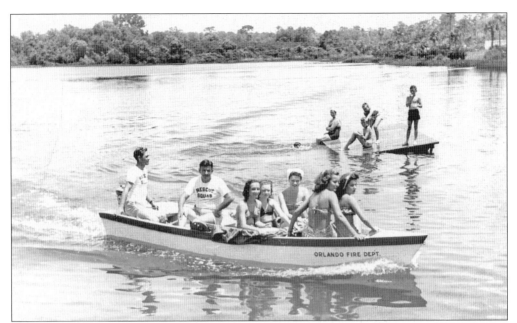

When a young person drowned in Lake Eola and could not be located in 1946, the Elks Club donated the first rescue boat that the Orlando Fire Department owned. Mel Rivenbark (left) and firefighter Person Bailey (right) tested out the glass-bottomed boat as soon as it was delivered. (Lt. Earl D. Horst Collection.)

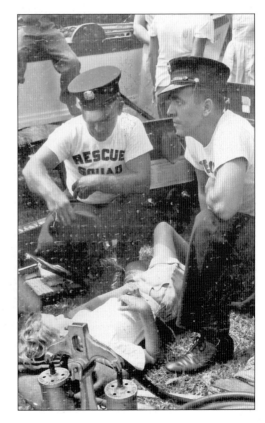

The original OFD dive and rescue team consisted of two members, depicted with a drowning victim around 1948. The equipment shown to the right of the victim's head is a hand-operated air supply that was connected by hose to a diving helmet. (Chief Randy Tuten Family Collection.)

Clyde Ethridge (right) answers citizens' questions pertaining to the new glass-bottom boat given to the Orlando Fire Department's dive and rescue team. The boat was publicly on display as a part of the 1946 Fire Prevention Week, since it was one of the department's newest acquisitions at that time. (Lt. Earl D. Horst Collection.)

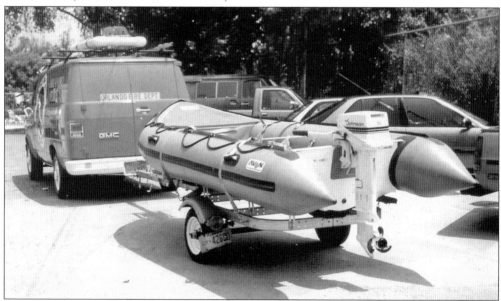

Though styles of boats have evolved, after September 11, 2001, the dive and rescue team keeps its equipment at Station One. On September 13, 1992, the rig was photographed behind the firehouse while leaving for a call. As of 2000, OFD also set up an antiterrorism task force, began an urban search and rescue unit, and combined fire and police dispatchers into one Orlando Operations Center. (Ed Read.)

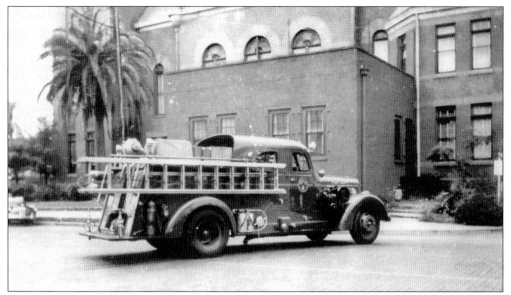

This 1942 Seagrave, known as Engine Number Nine, is backing into its firehouse around 1950. Around 1953, the department received three fire trucks to replace their existing 25-year-old models. Nearby communities purchased the older trucks, but the newer models were able to pump 750 gallons a minute. The triple combination pumper that was added to the department cost $17,180. (Chief Randy Tuten Family Collection.)

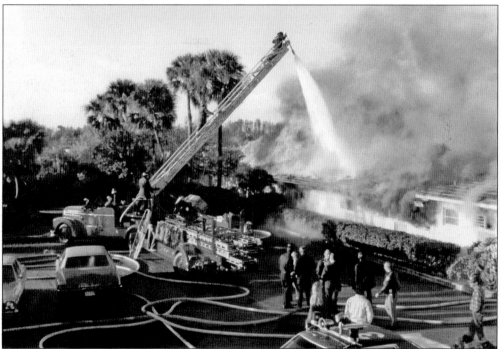

On February 23, 1977, multiple apparatus were called in to work against the fire at the Jamaica Inn. In 1940, a similar fire at a feed and seed company required five pumpers expelling 750 gallons of water a minute. The temperature was so intense at the feed and seed company that the building turned white with heat because it was built from corrugated iron. (Bob Cross.)

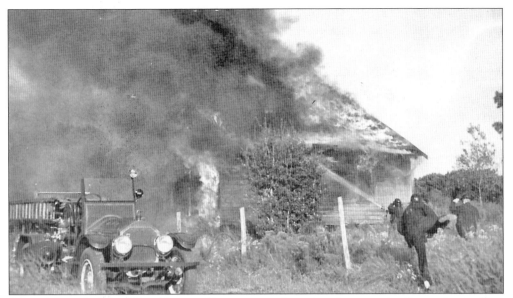

Station Three firefighters quickly scramble over a wire fence in order to reach a fire on the outskirts of town during the 1950s. At left is Engine Six. During this point in history, the fire department's apparatus was numbered as acquired, unlike today's vehicles that are numbered to correspond to the numbers of the stations where they are quartered. (Camnitz Collection.)

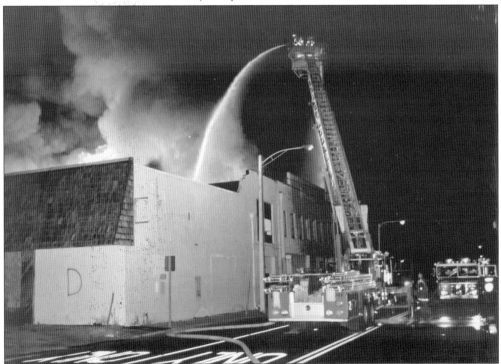

The Orlando Upholstery Company on Marks Street caught on fire on September 18, 1987, during the night. Scheduled for demolition, the building was visited by the fire department before bulldozers could complete their task. The initial cause of the fire was unknown, and multiple companies responded to get the flames under control. (Bob Cross.)

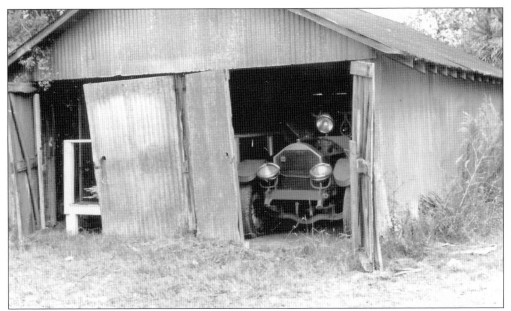

In 1990, the Orlando Fire Department's 1918 ladder truck was located in an old barn. The Florida Antique Bucket Brigade towed it to the Orlando Fire Museum for restoration. When the apparatus was removed from the barn, it was revealed that a garbage truck had backed into the truck before being rescued. The Apopka Fire Department donated the apparatus. (Camnitz Collection.)

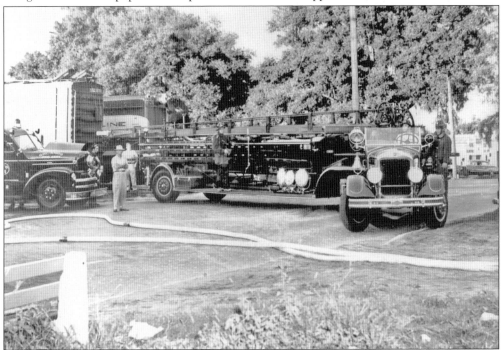

An order was placed in 1918 for the American LaFrance Motor Service Hook and Ladder Truck Type 14. It has four cylinders, a four-cycle engine with chain drive, 55-foot-long wooden ladders, and a tank beneath the driver's seat. Soda and acid could be combined in the tank to produce a chemical reaction for extinguishing fires. Total cost was $7,650. (Orlando Fire Department Archives.)

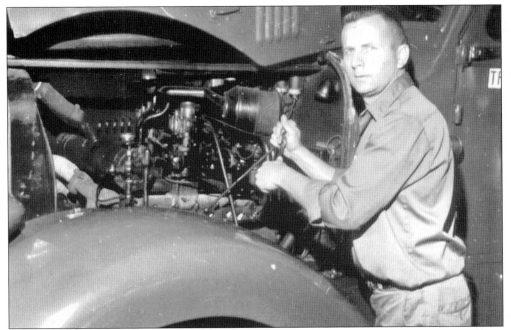

Around 1960, Walt Hurst is the chief mechanic working on a vintage Seagrave from the 1940s. Hurst was able to handle anything that happened to the fire apparatus regardless of the vehicle's era. His responsibilities covered vintage models through the more modern Sutphens. (Orlando Fire Department Archives.)

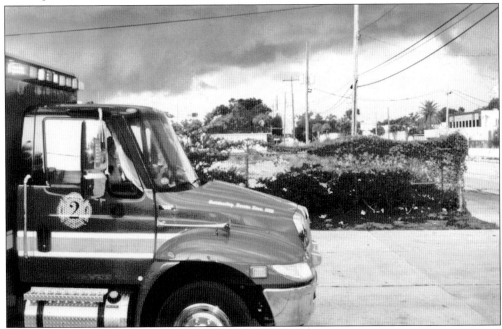

Rescue Two pulls out of the bays at Station Two as impending storm clouds hover over the neighborhood during the summer of 2006. Despite, and often because of, tropical storms, rescue operations continue out of all of the OFD firehouses. Weather conditions do not interrupt the regular duties of the firefighters. (Ginger Bryant.)

In 1948, firefighters practiced rappelling from the heights of the 1936 American LaFrance tiller aerial. Such expeditions were led by members of the department who had been through military training for rappelling. Today rappelling is a part of training for all firefighters. In 2006, Lt. Gerald Kasper of Station 13 practiced a civilian rescue using Daniel Ryan as a victim. (Ginger Bryant.)

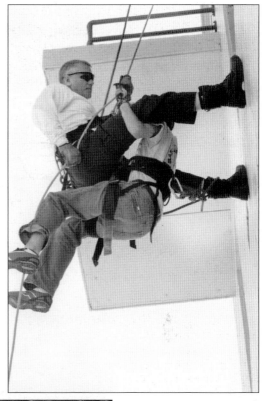

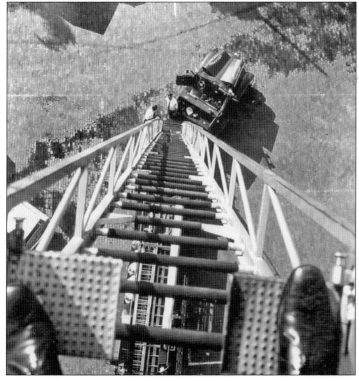

This photograph was taken from Tower One as a part of the Orlando Fire Department's Annual Report on February 1, 1971. By 1973, the department had 27 pieces of apparatus and 350 members. Woods 6, Woods 7, and Chemical 83 were added as available apparatus. Halligan tools and high-rise packs were used for the first time, and firefighters started working 42-hour weeks. (Orlando Fire Department Archives.)

In the 1950s, the Orlando Fire Department purchased new apparatus made by the American LaFrance manufacturer. In 1936, they added Aerial Ladder Truck Eight, shown around 1950. Somehow the number seven was skipped in the numbering of vehicles. It is unknown whether the omission was an oversight or something done for a particular purpose. However, there was no number seven until the 1950s. (Camnitz Collection.)

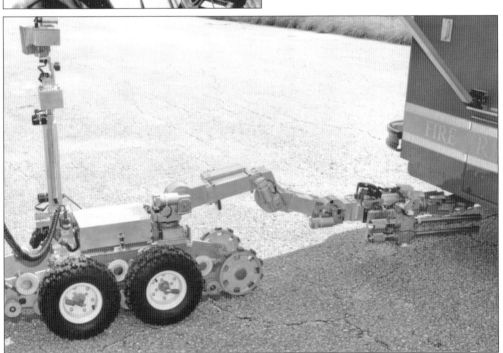

As seen in 2006, the arson and bomb squad gives demonstrations of its robot's abilities during sessions of the Citizens' Fire Academy. Able to reach under vehicles or stretch to a high shelf for searches, the robot is also equipped with a nine-gauge shotgun. Potentially threatening packages can be safely destroyed with this robot under controlled circumstances before unannounced explosions occur. (Ginger Bryant.)

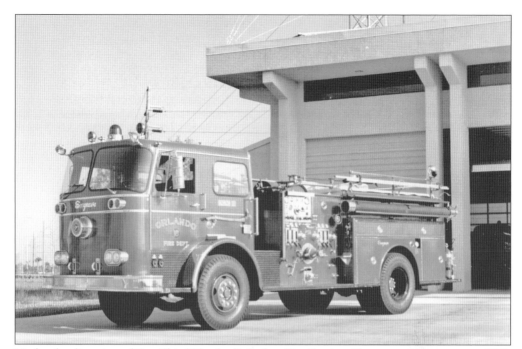

Under the direction of Fire Chief Charles S. Parker, Fire Station 10 was put into service in 1973, and Stations 11 and 16 were built, totaling 12 fire stations. The Seagrave was displayed outside Station 10 shortly after the firehouse's grand opening. (Chief Randy Tuten Family Collection.)

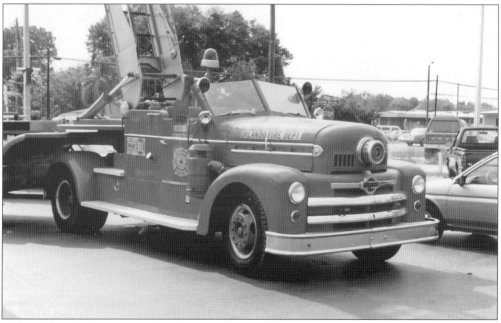

Old Ladder One was kept in reserve at Station Three in 1988. Nearly 10 years later, Chief Donald Harkins set up the rapid intervention team, which rescues firefighters in danger, installed Plymovent systems to remove exhaust from firehouses, placed thermal imaging cameras on all tower ladders so that firefighters would have infrared technology to use on the job, and acquired a disaster response trailer in 1996. (Camnitz Collection.)

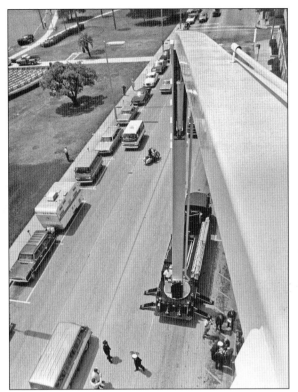

Firefighters riding in Snorkel Two have an unusual view of the apparatus' articulating arm from a height of 95 feet in the air around 1970. During the history of the department, there were periods of time when the addition of vehicles to the fleet was not economically possible. After 1926, there was a 10-year gap before another piece of apparatus was purchased. (Camnitz Collection.)

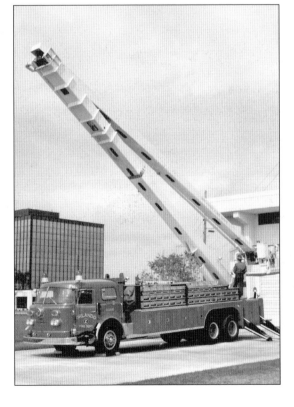

Snorkel Two was parked outside of Station 10 around 1975 when not being used for high-rise assists. The apparatus's price tag was quite different from the 1899 bill of $5,000 for a fire engine that was purchased by the city council from American LaFrance Fire Engine Company. (Chief Randy Tuten Family Collection.)

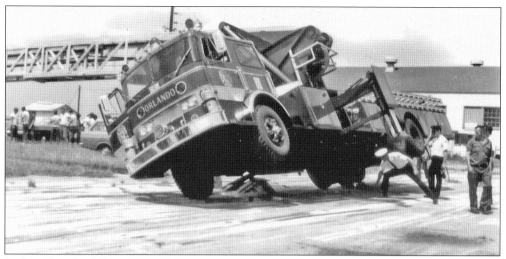

In the 1970s, firefighters are performing acceptance tests at Station Six, next to Herndon Airport. During the process, the asphalt gave way under the fire apparatus. Incidents such as this prompted Sutphen to provide auxiliary pads to be used under the jacks of their vehicles. (Orlando Fire Department Archives.)

The fire apparatus, a vital part of any firefighter's livelihood, is even celebrated in chocolate cake form. Desserts such as this one, created for a retirement party in the 1970s, pay tribute to the machine that replaced the trusty teams of horses that once pulled steamers. (Camnitz Collection.)

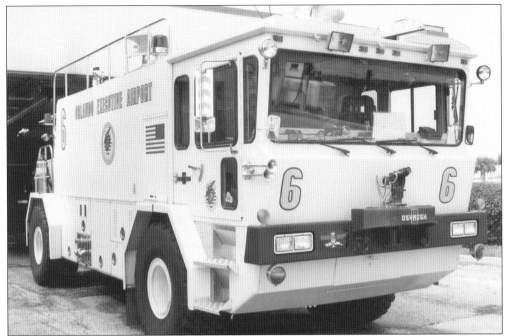

Crash Truck Six, pictured in 2006 at the Orlando Executive Airport, carries 1,500 gallons of water and gallons of foam, along with the other equipment such as hoses and nozzles. Unlike most apparatus, there is a joystick for maneuvering the nozzles inside the cab. Its bright, lime-green paint job aids in the task of maintaining high visibility on the runway. (Ginger Bryant.)

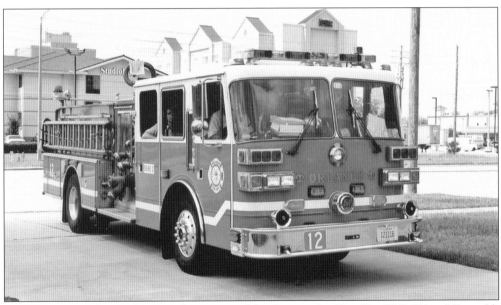

Engine 12, pictured around 1990, reflects many of the changes that Fire Chief F. E. "Gene" Reynolds established in 1977. In addition to changing the firefighters' work week to 49.8 hours, he installed flood lights on all engines and added a great deal of specialty apparatus to the department, including a hazmat van, dive and rescue van, a mini tower, and woods trucks. (Camnitz Collection.)

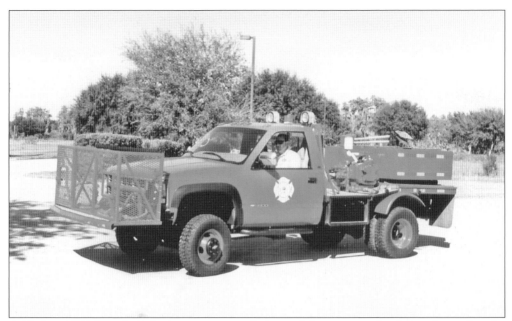

Added in 1977, Woods Eight became particularly vital during periods of drought in Florida. Firefighters are able to ride in the front cage-like structure of the apparatus, raising them above the brush fires so that hoses can be more easily manipulated from the front of the apparatus. (Camnitz Collection.)

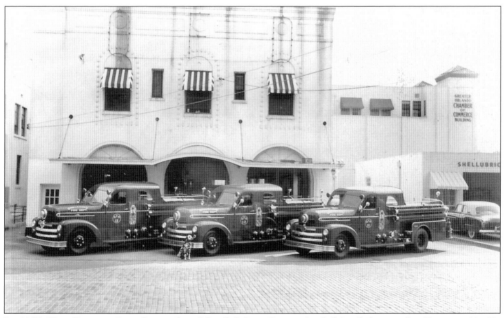

In 1953, Fire Station One, located on North Main Street, had, from left to right, Engines 11, 12, and 13. The Seagrave Anniversary Series was a new vehicle at the time, and the firefighters looked forward to putting the new apparatus through its paces. (Lt. Earl D. Horst Collection.)

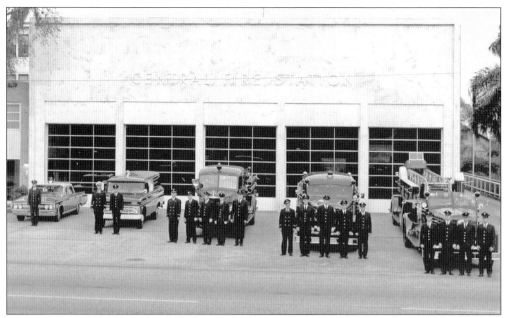

Station One, with all of its men and apparatus, was at the heart of all of the action downtown around 1960. Back in 1914, during a fierce electrical storm, members of the fire station on Oak Street feared for their lives. Virtually the entire roof of the firehouse was blown across the street, more than 50 feet away. (Camnitz Collection.)

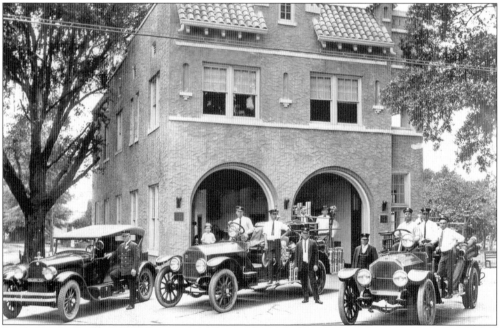

Firefighters proudly gather their equipment outside the original Station Two in the mid-1920s. In 1915, for $6,000, the department purchased a motor fire truck that was a combination hose and chemical fire apparatus. It came with 1,200 feet of hose, one extension ladder, one roof ladder with folding hooks, two nozzles, a pike pole, four lanterns, tools, and room for 12 firefighters. (Chief Randy Tuten Family Collection.)

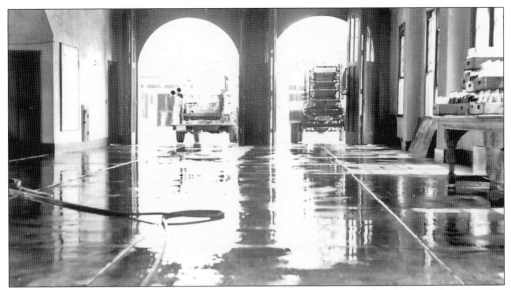

With the shiny, wet floors of Station Two during the mid-1940s, it had to be Saturday. This day of the week is the traditional "scrub day" for the station, even in this decade. Old Ladder Three can be seen just outside the bays. (Lt. Earl D. Horst Collection.)

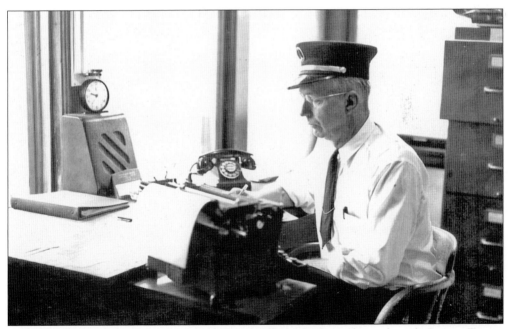

Lt. Earl D. Horst worked inside the Civil Board Office, which was located inside Station Two in 1945. Fire Station Two officially opened in 1925 but eventually outgrew the amount of activity taking place at this firehouse, and it had to be torn down. Its replacement was also built on the corner of Parramore Avenue and Central Avenue. (Lt. Earl D. Horst Collection.)

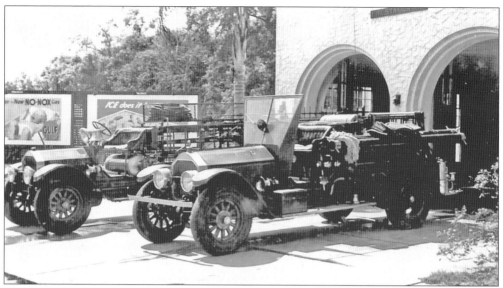

Engine Three (left) and Engine Five are parked outside Station Two in the early 1950s. In the 1960s, Station Two was torn down, and the new station opened in 1966. This structure, lovingly referred to as "the Pride of Parramore," was the busiest firehouse in the state of Florida according to the 2004 Run Survey. (Lt. Earl D. Horst Collection.)

Station Four stood its ground in the early 1990s despite the fact that it was decommissioned during the Depression. When the first fire station in Orlando was decommissioned in 1919, plans were made to turn the existing fire station into a "curb market," or public market where people could sell their vegetables. Fire Station One was moved from Wall Street to Main Street. (Camnitz Collection.)

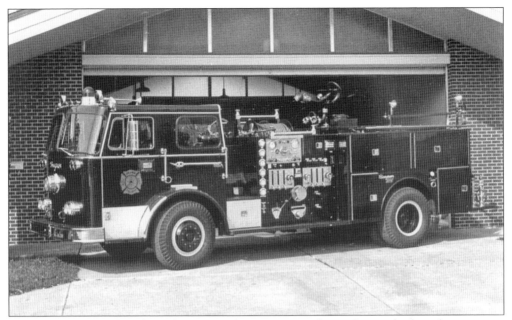

Station Five, pictured in the early 1970s with a Seagrave in front of it, was built in the same year and style as Station Four. The department also experienced growth in 1915, when the annual cost of maintaining the fire department was $3,753.76. (Chief Randy Tuten Family Collection.)

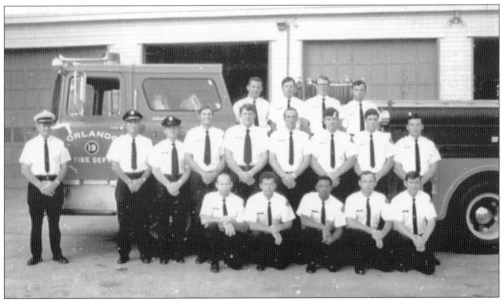

The 1971 training class met with Station Six's B Shift and then gathered in front of Engine 19 as a souvenir for the new crop of hopefuls. It was in 1979 that a new Station Six was built in a new location, and the National Fire Incident Reporting System was started. (Orlando Fire Department Archives.)

Station 10 was built in 1973, with its apparatus photographed around 2005. Twenty-three years after this station was built, in 1996, the first fire chief to be state-certified as a paramedic was Chief Donald W. Harkins. He served on the professional development and arson committees of the International Association of Fire Chiefs and replaced all protective clothing for firefighters. (Camnitz Collection.)

A parade of apparatus departed from Station 11 as a British fire buff stood on the sidewalk with camera in hand to capture the moment around 1995. As of 1977, the entire department was state- and county-certified as a life-support provider. This additional service increased call volume, as the firefighters could be employed on virtually any scene. (Camnitz Collection.)

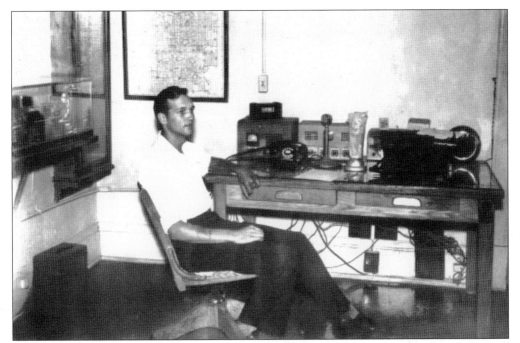

Larry L. Camnitz sits at the core of the Communications Center as it appeared in 1950. Call volume had increased since 1920, and technology had to keep up with Orlando's needs. When tallies were taken for the year 1920, it was revealed that there were 37 alarms sounded for the fire department over the course of the past 12 months. (Camnitz Collection.)

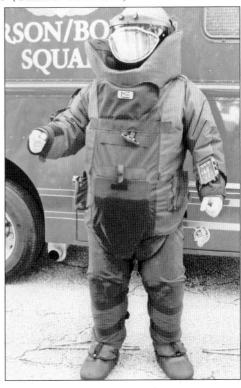

The Orlando Fire Department's arson and bomb squad has extended its communication capabilities into the suits of those who investigate explosive materials in close proximity. Each suit, as depicted in 2006, is outfitted with a communication device that enables the armored investigator to carry on a dialogue with other members who are monitoring their progress at a distance. (Ginger Bryant.)

In 1978, old Fire Station Three, no longer in use, was moved to Loch Haven Park. It was converted to the Orange County Historical Museum in 1984, when Orlando's population was 143,000. It was at this point that it became the site of the Orlando Fire Museum. (Orlando Fire Department Archives.)

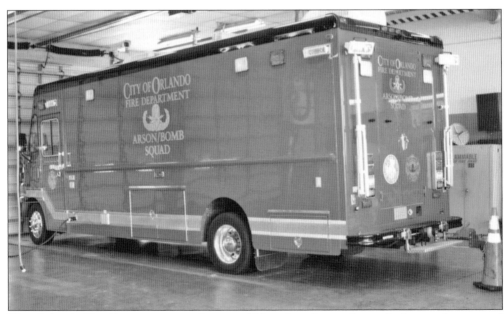

The Orlando Fire Department took care of Herndon Airport's needs during the time of transformation from McCoy Air Force Base to a public airport in the 1970s. Once the airport was no longer manned by the military, the firehouse became known as Station Six. It serves as the home of the Arson and Bomb Squad, as seen in 2006. (Ginger Bryant.)

*Four*

# Practice, Prevention, and Public Relations

With Mayor W. H. Reynolds in office, 1911 marked the advent of a more fire conscious Orlando. A new ordinance designed to provide further protection for places of amusement was announced. As a part of the new guidelines, doors opening inward were no longer allowed, moving picture shows were required to have a minimum of two exits, and movie theaters could no longer be constructed from wood. Stages were required to have asbestos curtains that could be lowered instantly in order to cut off the scenery and materials on stage from the rest of the main house where the audience is seated. Those in violation of this ruling could be fined up to $500, sentenced to 60 days of imprisonment, or some combination of the two.

The next month, C. Robinson, a member of the fire company, saw a fire at the Atlantic Coast Line freight depot, Walker Brothers packinghouse, and the Citrus Exchange packinghouse. Robinson's eyebrows were singed when he burst through the door of the freight office as a first responder to the scene. While fruit was salvaged, much of the machinery was lost. During the blaze, four cases of dynamite exploded in the depot, and six or seven loaded freight cars were destroyed. One such freight car contained coal and had to be pulled out of the depot to prevent further damage from taking place. Water pressure was lost during the fire because the main next to the standpipe burst. The origin of the fire was unknown, but many suspected that sparks from an engine switching tracks probably started it.

The next year, city officials reflected on this 1911 fire and commented on how close the packinghouse flames came to the school. Fire drills were then introduced to area schools, and a ruling was passed requiring all buildings located in the center of downtown to be replaced by 1913 if constructed of wood. Prevention was the new tactic of the era.

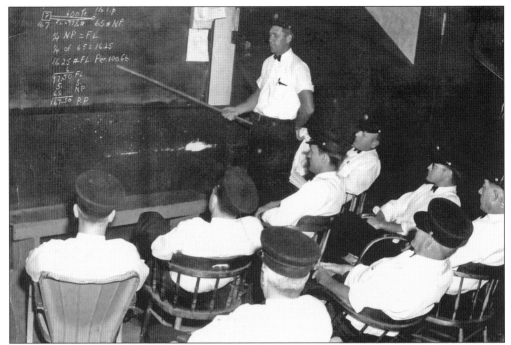

Around 1945, instructor M. W. Rivenbark leads a class that kept firefighters current on practices in the field. Students are, from left to right, (first row) V. A. Spence, L. F. Gilliam, Larry L. Camnitz, and George Felton Tuten; (second row) D. L. Pennington, E. O. Cooper, S. C. Teed, and H. L. Hall. (Lt. Earl D. Horst Collection.)

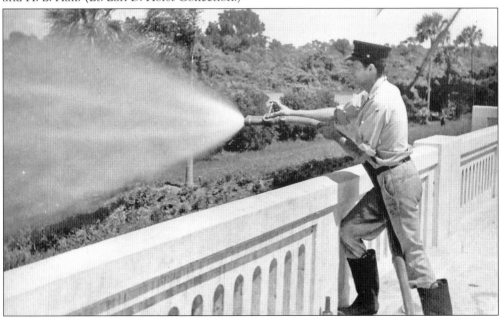

In the early 1950s, Larry Camnitz sharpens his skills with the hose line at Lake Ivanhoe. About this time, the Civil Service Board began requiring entrance examinations for the Orlando Fire Department in 1953. Applicants had to be white males between the ages of 21 and 30 who had lived in Orlando for at least one year. (Camnitz Collection.)

During the late 1960s, live burns were used for practice sessions. These firefighters were extinguishing a set fire in the army and air force base barracks. The barracks had to be cleared when some of the military facilities were pulled from Orlando, and the Orlando Fire Department was more than happy to assist with that process. (Dick Camnitz.)

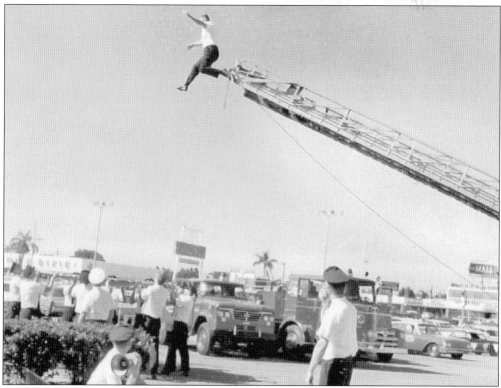

A trusting firefighter leaps from a ladder into the net of his fellow company members during a practice and demonstration held in 1967. Combining community relations with daily drills, this practice was conducted in the parking lot of a shopping center so that onlookers could observe typical rescue routines. (Orlando Fire Department Archives.)

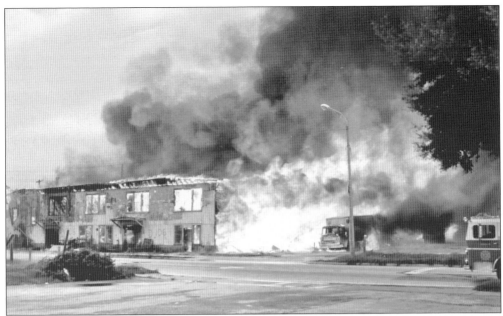

On September 6, 1985, the Southeast Steel warehouse caught on fire in Orlando. The fire was in more advanced stages of destruction before the Orlando Fire Department was called in to respond. Because the fire was located on Amelia Street, smoke could be seen throughout most of downtown Orlando. (Bob Cross.)

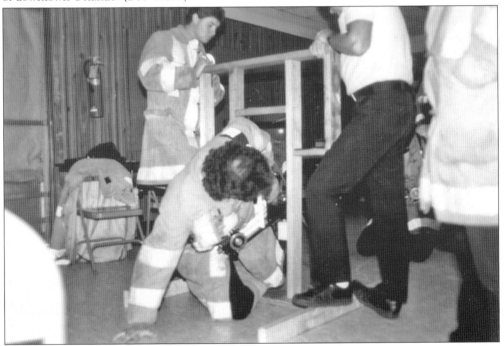

Around 1993, firefighters were given training for scenarios involving entrapment in a burning room. With all exits barricaded, firefighters were shown how they could knock holes in walls, remove their air tanks, and crawl between studs in a wall. Though labor intensive, such escape routes would save lives during extreme conditions. (Chief Randy Tuten Family Collection.)

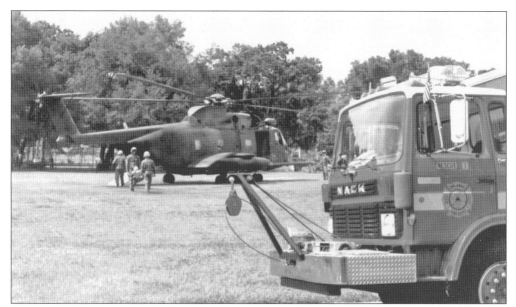

In the early 1990s, astronauts from NASA were flown from Titusville, Florida, to Delaney Park in Orlando as a part of an emergency drill. The 49-mile trip was completed in 14 minutes while flying in government aircraft. The Orlando Fire Department was graded on its response time to the mock disaster. (Chief Randy Tuten Family Collection.)

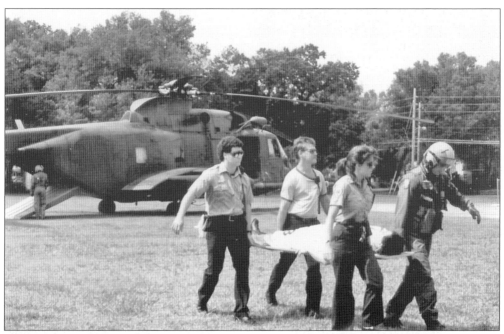

During the c. 1991 NASA emergency drill, four astronauts were flown to Orlando, each with his own doctor. The Orlando Fire Department was utilized in the transportation of the astronauts to the Orlando Regional Medical Center. The drill simulated conditions that would occur in the case of malfunctions during shuttle launch at the Kennedy Space Center. (Chief Randy Tuten Family Collection.)

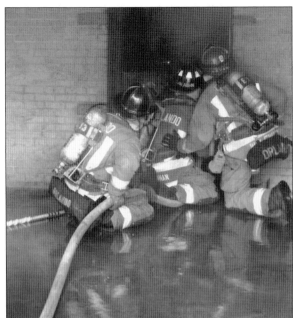

OFD firefighters huddle up in anticipation of their session inside Burn House. This multi-level structure is a part of the Central Florida Fire Academy. Here firefighters practice in a series of rooms that simulate different fire scenarios, all controlled by gas valves operated from the exterior. (Ginger Bryant.)

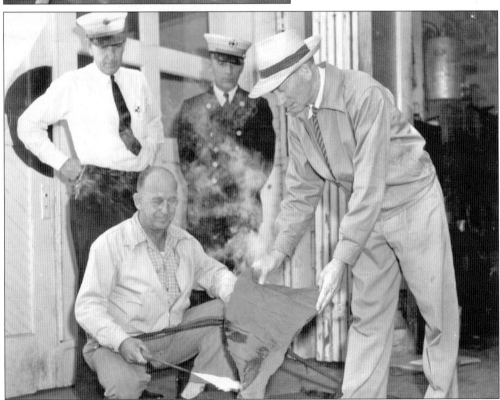

Chief Maxie Bennett (left) is joined by Assistant Chief Loy Davis (standing center) during a fire demonstration staged to show the effects of flame retardant materials around 1948. A few years earlier, in 1944, the U.S. Department of Commerce gave the Orlando Fire Department a certificate of national recognition for its outstanding work in fire prevention. (Camnitz Collection.)

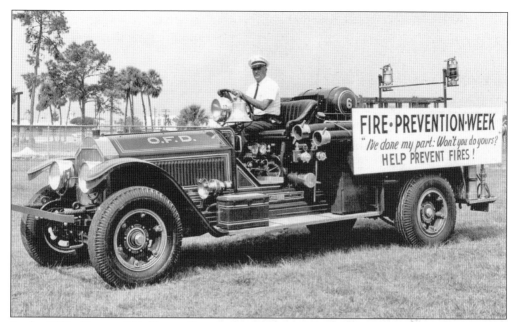

In the 1950s, Deputy Chief Larry Camnitz and other members of the Orlando Fire Department participated in Fire Prevention Week. Mayor W. H. Reynolds first proclaimed October 8, 1911, as Fire Prevention Day, and the next day, an article appeared in the newspaper asking people to quit striking matches on doors and window ledges as a means for preventing fire. (Camnitz Collection.)

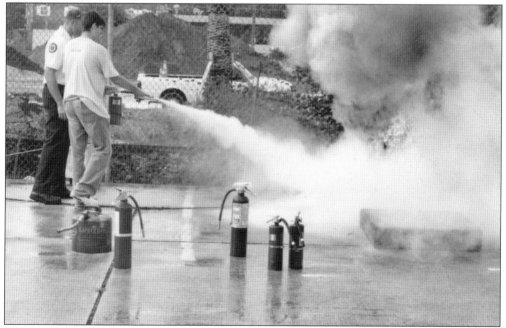

In July 2006, Lt. Walter Lewis taught Citizens' Fire Academy participant Philip Rossman-Reich the correct way to use a fire extinguisher so that flames on a liquid flammable substance would not spread. In 1990, the Orlando Fire Department continued its involvement in schools by converting a trailer donated by Universal Studios into a mobile fire-safety educational unit for local grade-school children. (Ginger Bryant.)

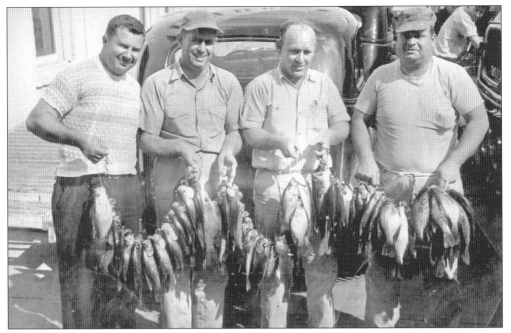

Walter Tedder (left), pictured around 1948 with his fellow firefighters and fishing companions, brought their enormous catch to the rear of the firehouse. Their camaraderie at the firehouse extended into their leisure time. Such expeditions often resulted in large fish fries that all hungry firefighters anticipated. (Chief Randy Tuten Family Collection.)

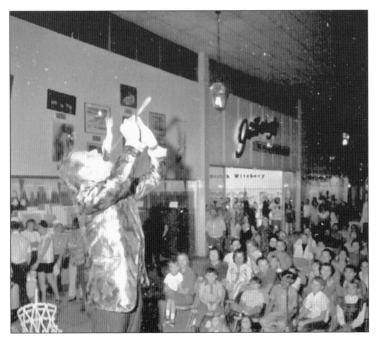

Fire Prevention Week 1972 showcased all types of entertainment intended to lure crowds toward displays on fire safety. Ironically, during an October 11 show performed inside the Colonial Plaza Mall, a magician was hired by the Orlando Fire Department to display his fire eating skills. (Orlando Fire Department Archives.)

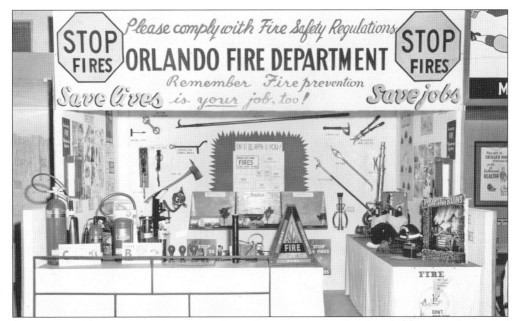

The April 27, 1914, issue of the *Evening Reporter* newspaper revealed that during 1913, the United States and Canada combined lost $230 million worth of belongings to fire. The newspaper called for more precaution and education to prevent such loss in the future. By the 1970s, mall displays such as this one reminded viewers to, "Remember, fire prevention is your job too!" (Chief Randy Tuten Family Collection.)

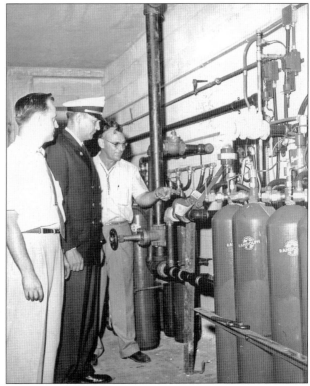

In the 1950s, fire inspections were conducted in places of business to make sure that conditions met existing, but somewhat minimal, codes. Here the new cascade system at the *Orlando Sentinel* was being checked. By maintaining a visual presence, the Orlando Fire Department was able to serve as a reminder to citizens to be watchful in their personal surroundings. (Camnitz Collection.)

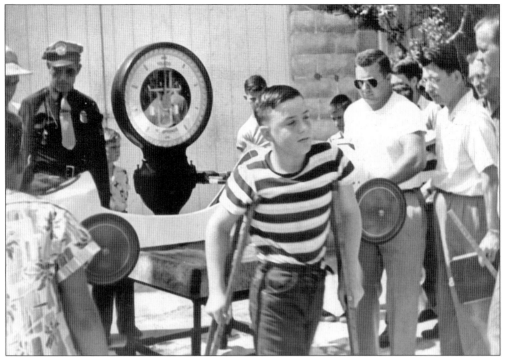

Always willing to get involved with charitable causes within the community, the Orlando Fire Department sponsored Roy Landis in the 1952 soapbox derby. Roy (center) had polio and raced for a cause very personal to him. Walt Tedder is seen loading the soapbox derby car onto a scale prior to the race to ensure that the vehicle meets all of the race's regulations. (Camnitz Collection.)

Around 1954, Roy Landis prepares to compete in the annual soapbox derby. His soapbox creation sports the number nine, which corresponds to the number of the engine that backed both Roy and all of his efforts. Firefighters always turned out to watch Roy compete. (Camnitz Collection.)

Prior to the days of mall exhibits, the streets of downtown Orlando were littered with displays pertaining to fire prevention every October. Even the rescue boat and other pieces of equipment were put on view around 1946, as firefighters were on hand to answer questions. (Camnitz Collection.)

By familiarizing small children with apparatus and its specific functions, some of the fear is removed when rushing engines are later seen moving through traffic. In September 1967, regular tours of firehouses were given to children in order to increase their awareness of fire safety. (Orlando Fire Department Archives.)

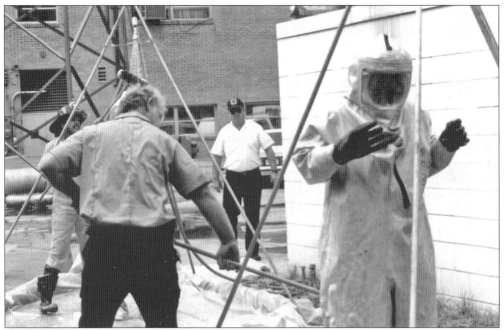

Chief Randy Tuten (third from left) oversees rehearsal of scenarios requiring the use of chemical suits to protect firefighters from contaminants. It was also during the early 1990s that the emergency medical dispatcher system was started, and fines were put in place for excessive false fire alarms. (Chief Randy Tuten Family Collection.)

Depicted in 2006, Burn House, located at the Central Florida Fire Academy, offers firefighters the opportunity to practice with live gas-fire drills on the first and second floors of the structure. Additionally, the third floor enables participants to work with Class A combustibles and work on mock scenarios involving high-rise structures, complete with an elevator. (Ginger Bryant.)

On December 4, 1971, the Orlando Fire Department constructed a float warning citizens, "Don't let fire destroy your Christmas." The float was hooked to the back of an apparatus and added to the Christmas parade. Today the Orlando Fire Department participates in the annual Citrus Bowl Parade during the holidays, and its OFD Pipes and Drums Band proudly lends music to the march. (Orlando Fire Department Archives.)

In the mid-1970s, fire departments from Germany and Luxembourg brought 186 members to tour the United States, making stops at firehouses across the country. Escorted tour buses arrived in front of Station One to be greeted by both the American and German flags flying atop aerial apparatus. (Camnitz Collection.)

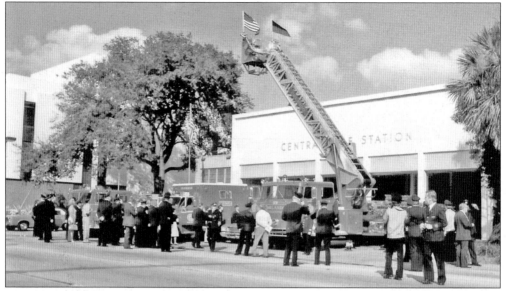

On a quest to discover similarities and differences between German and American firehouses, on October 26, 1976, the German firefighters brought gifts so they could share something of their country with their American hosts. Orlando provided the visiting firefighters with the largest welcome, and consequently received presents from Germany, some of which had been meant for other, less cordial American cities. (Camnitz Collection.)

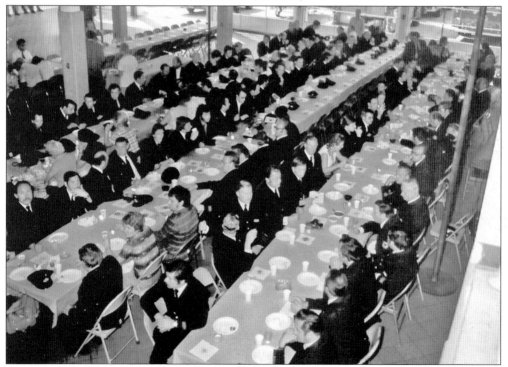

The bay of Station One in 1976 was converted to a reception area for the visiting German firefighters so that a large lunch could be served. The visitors were also treated to a night out at the Rosie O'Grady's entertainment complex during their visit to Orlando. (Camnitz Collection.)

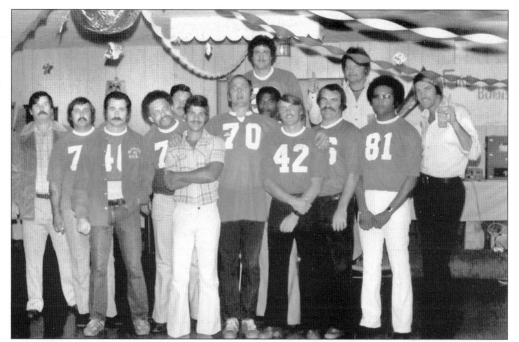

In 1978, the annual tradition of the Orlando Fire Department playing football against the Orlando Police Department started under the name Fire v. Fuzz. The first year, the Orlando Fire Department won with a score of 33-6. The OFD team gathered for an after party around 1979. (Chief Randy Tuten Family Collection.)

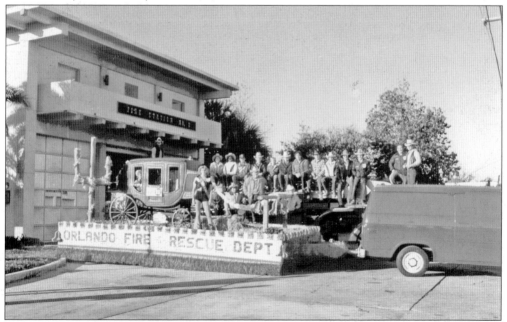

In conjunction with the Boy Scouts of America, the Orlando Fire Department started the OFD Explorer Post in 1980, enabling young boys and teenagers interested in fire service to begin working toward a career in the field. Around 1987, the Fire Explorers position themselves on a Christmas float in front of Station Two prior to a parade. (Chief Randy Tuten Family Collection.)

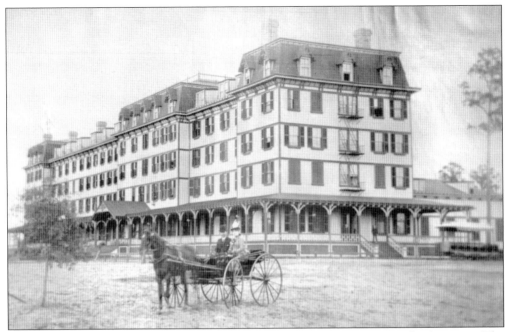

The largest hotel to the south of Jacksonville opened on January 1, 1886, with 150 rooms. The Seminole Hotel saw 2,300 guests during the first three months of its operation, including notables such as President Arthur and President Cleveland, who visited prior to the fire. (Department of College Archives and Special Collections, Olin Library, Rollins College, Winter Park, Florida.)

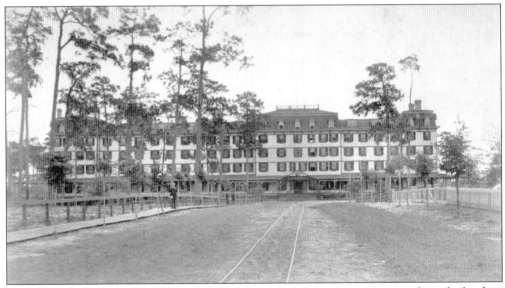

The Seminole Hotel was 300 feet long and four stories high, but fire originating from the kitchen at 3:00 a.m. on September 18, 1902, ended the hotel's splendor. In the lot next to the hotel, random valuables began to amass as volunteer firefighters pulled belongings from the hotel for as long as possible. (Department of College Archives and Special Collections, Olin Library, Rollins College, Winter Park, Florida.)

# Five

# MUTUAL AID

Winter Park, included under the banner of the Greater Orlando area, formed its own volunteer fire department in 1900 just as fire hydrants and mains were being installed, reducing the response area for the Orlando Fire Department. Despite such territorial distinctions, the two fire departments continued to team together for large emergencies, providing support for each other on a situational basis. Such collaboration was first put into action in 1902 for an enormous fire at the Seminole Hotel on the shore of Lake Osceola in Winter Park. Without any fire apparatus, the Winter Park volunteers could only watch the fire spread for an hour as they attempted to remove valuables from within the hotel. The Orlando Fire Department was also called in to assist, and they were able to arrive with the hook-and-ladder truck. However, there was nothing that could be done against a fire of this size.

Such mutual aid continued over time. In 1955, all three Orlando Fire Department companies—the Winter Park, Orlando Air Force Base, and Holden Heights departments—were called on the night of May 23, when the 60-room Avalon Hotel on North Orange Avenue was engulfed in flames. However, one of the more historic pairings took place on Easter Sunday, April 6, 1969, and marked the advent of the first enclosed mall fire in the history of the United States. When flames became visible on the roof of the Winter Park Mall, the Orlando Fire Department, Killarney Volunteer Fire Department, and Maitland Fire Department all arrived to lend support to the Winter Park Fire Department, which was already on the scene as first responders. All four departments worked to battle the flames for over four hours.

In 1980, a joint response agreement was set up between the Orange County and Orlando Fire Departments so that large emergencies could utilize the services of both departments. As a result, all fire departments in the Greater Orlando area are able to work together and respond to emergencies regardless of differences in their standard operating procedures. The result is a well-cared-for populace.

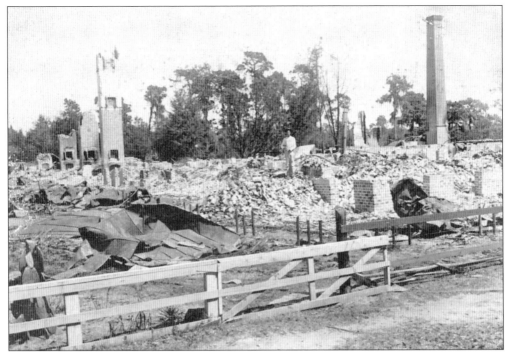

The remains of the Seminole Hotel on September 25, 1902, included the body of a worker from the Palms. The worker was repeatedly sent inside the Seminole Hotel until there was a large explosion, and the man never reemerged. The fire raged out of control until 7:00 a.m.; its cause was never known. (Department of College Archives and Special Collections, Olin Library, Rollins College, Winter Park, Florida.)

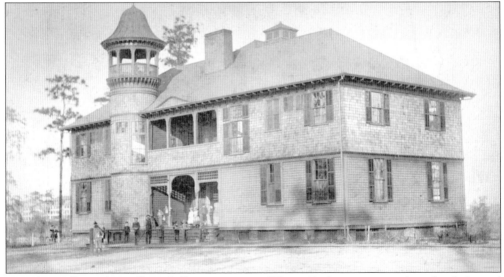

Knowles Hall, on the Rollins College campus in Winter Park, was not ready to be dedicated until March 9, 1886. At the dedication of the building, there was a bell with an inscription to commemorate the origins of the college, but that bell melted in the fire of 1909. (Department of College Archives and Special Collections, Olin Library, Rollins College, Winter Park, Florida.)

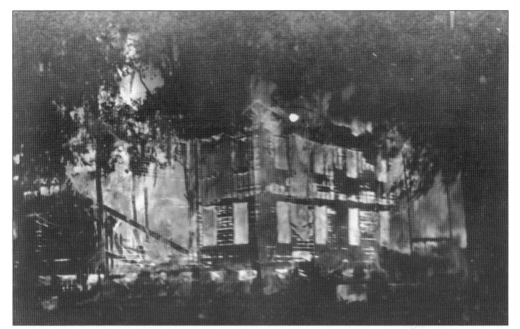

On December 1, 1909, the first building in the state of Florida to be constructed specifically for college classes burst into flames, requiring the services of Winter Park and Orlando firefighters. Only 30 minutes into the Rollins College fire, its walls fell outward toward firefighters working the hose lines. (Department of College Archives and Special Collections, Olin Library, Rollins College, Winter Park, Florida.)

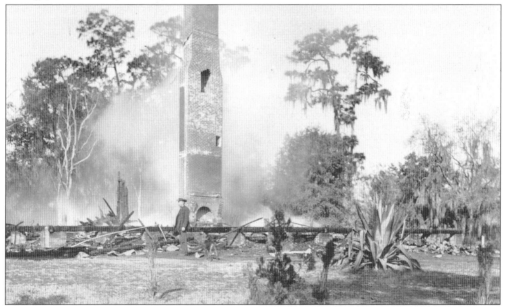

While the 1909 fire started at the switchboard in Knowles Hall, no one knows what triggered the flames. Dr. Thomas R. Baker was perhaps most upset because he had been working on a collection of specimens for 20 years that was lost to the fire. All that remained was a chimney. (Department of College Archives and Special Collections, Olin Library, Rollins College, Winter Park, Florida.)

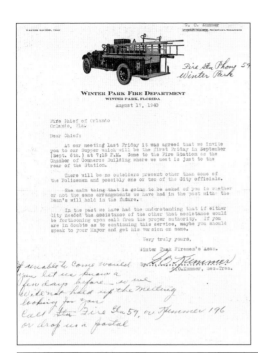

On August 17, 1940, the secretary/treasurer of the Winter Park Firemen's Association sent a letter to the Orlando Fire Department expressing a desire to continue supplying mutual aid to the citizens. G. O. Kummer explained, "In the past we have had the understanding that if either City needed the assistance of the other that assistance would be forthcoming upon call from the proper authority." (Winter Park Fire Department.)

In an August 25, 1940, reply from the Orlando Fire Department, the invitation to meet with the Winter Park Firemen's Association was accepted. After the death of Chief Gideon Dean, it was feared that the Orlando Fire Department would not continue to assist neighboring departments any longer. However, that fear was quickly put to rest, and cooperative efforts between the fire departments continued. (Winter Park Fire Department.)

# City of Orlando
## Orlando, Florida

August 25, 1940

Winter Park Firemens Assn.

Winter Park, Fla.

Dear Mr. Kummer:

I am Indeed Very sorry Ihave not answered your letter long before this, but you realize the sudden death of Chief DEAN has left us in a state of upset,However, I will consider it a great pleasure to meet with you on Sept. 6th. at 7:15 P.M.

Very truly yours,

Chief

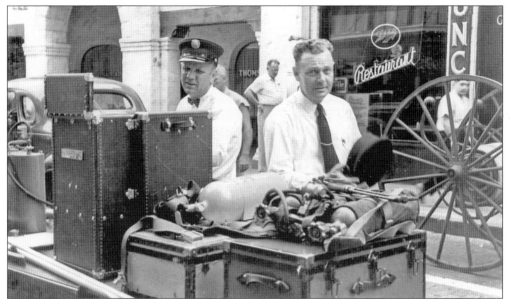

Ed Gilliard (left) and Chief Paul Pennington exhibit equipment during Fire Prevention Week in 1946. Nine years later, Chief Pennington was at the Avalon Hotel fire that required seven pumpers, 14 lines of 2.5-inch hose, an additional 2,650 feet of 1.5-inch hose, and what amounted to 398 feet of ladders from multiple fire departments. (Lt. Earl D. Horst Collection.)

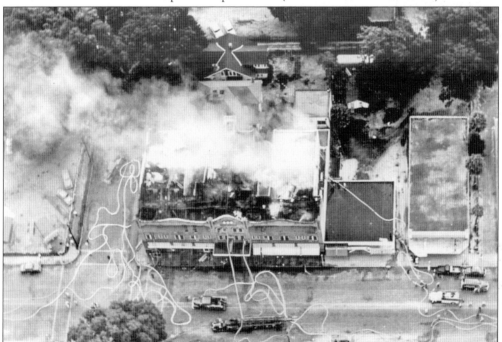

Chief Pennington believed that overloaded wiring at the Avalon Hotel on March 23, 1955, led to its destruction because a fuse box had been bridged. All three Orlando Fire Department companies—the Winter Park, Orlando Air Force Base, and Holden Heights departments—were called to the scene. The battle against the fire lasted over four hours, and water damage from intervention was extensive. (Bob Cross Collection.)

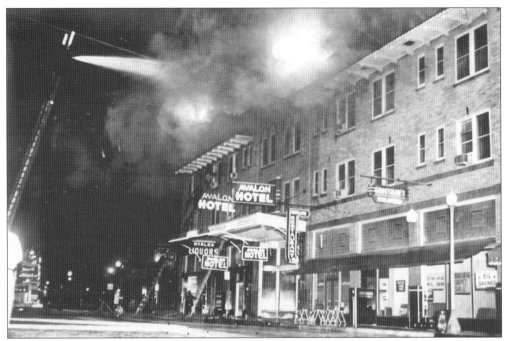

According to a report by the *Orlando Sentinel*, fireman J. R. Spence had a premonition regarding the devastating Avalon Hotel fire. On May 19, 1955, just four days before the large fire on May 23, Spence dreamed several details about the fire, including the bridged fuse in the tavern on the ground floor. Additionally, just as Spence dreamed, the fire occurred on his day off. (Bob Cross Collection.)

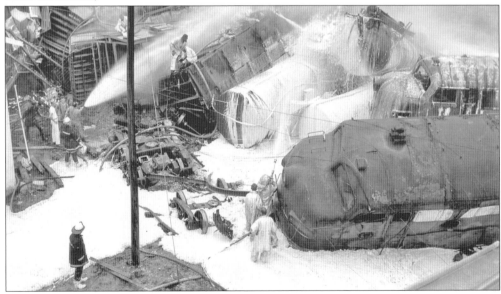

On June 13, 1962, one of the Atlantic Coastline Railroad's trains derailed when a car made an impulsive left turn in front of the locomotive. Firefighters from multiple departments arrived to see cars strewn about the tracks, but they were able to contain fire using foam. Rescue efforts were so extensive that it was 1:00 a.m. before all of the wreckage could be cleared from the site. (Bob Cross.)

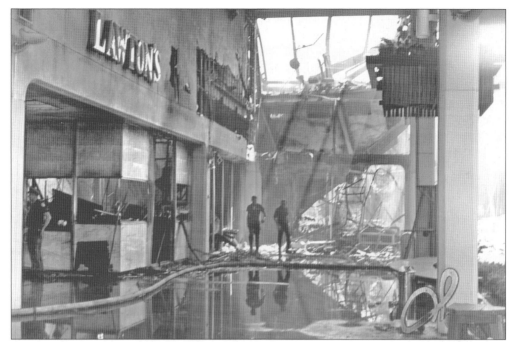

Shortly after 5:00 a.m., April 6, 1969, a burglar alarm from Lawton's Jewelry store in the Winter Park Mall was noted by police as a malfunction. However, the mall, with 450,000 square feet of retail space, was already in the throes of advanced fire. Without detection from the exterior, flames were working toward the upper level of the mall. (Winter Park Fire Department.)

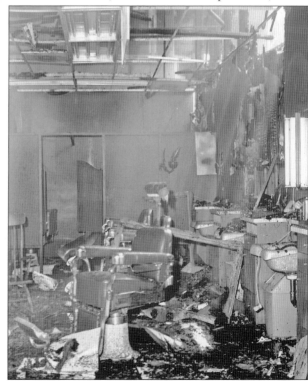

One of the problems of the 1969 Winter Park Mall fire stemmed from the fact that partitions between stores did not extend beyond the suspended ceiling. As seen in the remnants of Augie's Barber Shop, fire found an easy corridor above stores, where flames could travel and drop into the various shops. (Winter Park Fire Department.)

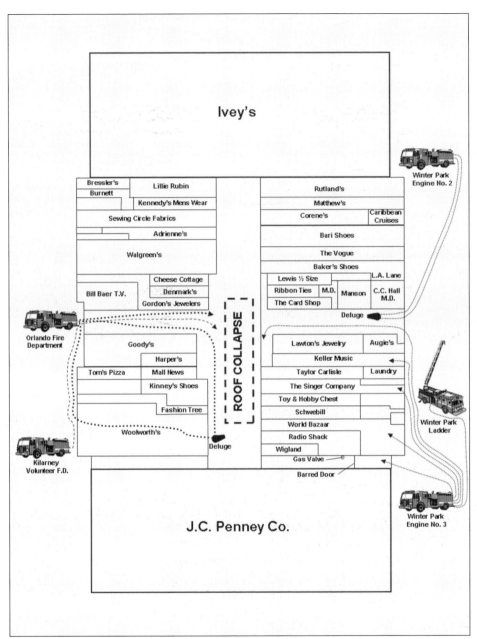

The following labels appear in the diagram:

Ivey's

Bressler's
Burnett
Lillie Rubin
Kennedy's Mens Wear
Sewing Circle Fabrics
Adrienne's
Walgreen's
Cheese Cottage
Bill Baer T.V.
Denmark's
Gordon's Jewelers
Goody's
Harper's
Tom's Pizza
Mall News
Kinney's Shoes
Fashion Tree
Woolworth's
Deluge

Rutland's
Matthew's
Corene's
Caribbean Cruises
Bari Shoes
The Vogue
Baker's Shoes
Lewis ½ Size
L.A. Lane
Ribbon Ties
M.D.
Manson
C.C. Hall M.D.
The Card Shop
Deluge
Lawton's Jewelry
Augie's
Keller Music
Taylor Carlisle
Laundry
The Singer Company
Toy & Hobby Chest
Schwebill
World Bazaar
Radio Shack
Wigland
Gas Valve
Barred Door

ROOF COLLAPSE

Winter Park Engine No. 2

Orlando Fire Department

Winter Park Ladder

Kilarney Volunteer F.D.

Winter Park Engine No. 3

J.C. Penney Co.

The Orlando Fire Department added a deluge set with three lines at the Winter Park Mall fire of 1969. Simultaneously, the Winter Park Fire Department used a deluge set in the east entrance with 2.5-lines. Winter Park's Fire Department was pumping 1,000 gallons per minute from Engine Three and 750 gallons per minute from Engine Two. The Kilarney Volunteer Fire Department also ran a line on the west side of the mall. When the deluge set was put into motion, ceiling tiles were knocked out, revealing fire spreading overhead. Additionally, gas lines could not be cut off as soon as desired because the door to the control room was barred. It became evident that the fire originated in the Singer Sewing Center and Taylor Carlisle Book Store area, but the cause could not be determined. (Diagram by Arbadella Asher Bryant based on sketches provided by the Winter Park Fire Department.)

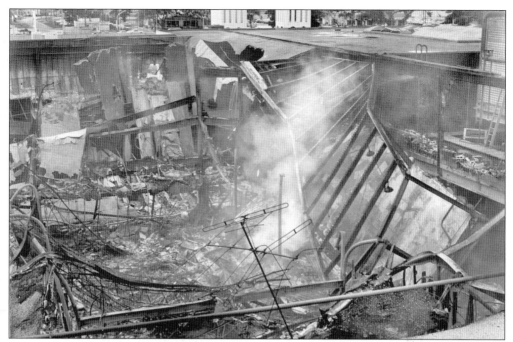

There were party walls supporting more than one section of roof in the Winter Park Mall fire of 1969, and steel supports did not have any fire-resistant protection. While a large section of roofing collapsed, the greatest injury on location was a cut finger and blisters on firefighters' feet. One canary at Woolworth's was lost due to smoke inhalation. (Winter Park Fire Department.)

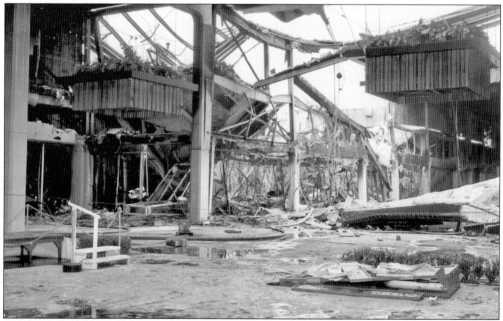

With a collapsed section of roof inside the Winter Park Mall, flames reportedly shot 30 to 40 feet above the mall as gas lines could not be shut off immediately. While notices had to be given on television, demanding spectators to stay away from the fire of 1969, crowd control was still needed for the 50,000 viewers on site. (Winter Park Fire Department.)

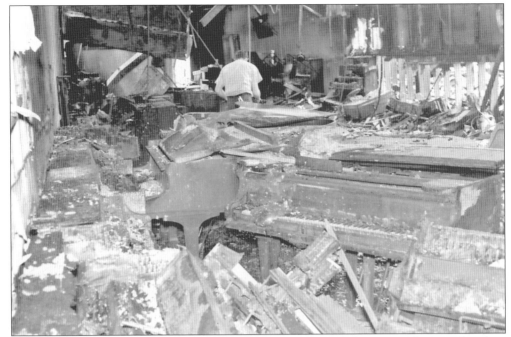

The Keller Music Company, like other Winter Park Mall stores, lost most of its merchandise. However, the cause of the fire could never be determined, despite the efforts of investigators from various parts of the country. Nearby, Frisch's gained $156.83 after firefighters devoured 310 hamburgers. In 1969, the Orlando Fire Department was also thanked by Winter Park's mayor for providing strong aid. (Winter Park Fire Department.)

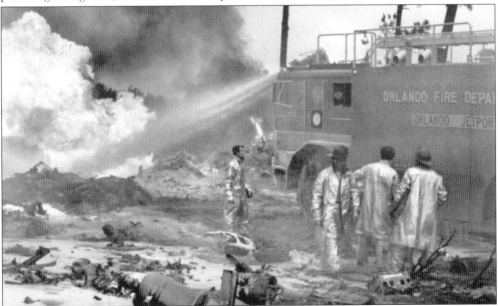

On March 31, 1972, the Orlando Fire Department was called in when a B-52 was having difficulties. Along with multiple fire departments, OFD members witnessed the plane going down, crashing on the runway. At the completion of the tragic day, it looked like snow had fallen in Florida because so much foam was needed to extinguish the blaze. (Bob Cross.)

On February 14, 1974, the Winter Park Fire Department was called to the ground floor of the Lyman Gym at Rollins College, where flames were seen. Smoke was pouring out of the second floor. Other departments in the area, including the Orlando Fire Department, were called to provide mutual aid. (Department of College Archives and Special Collections, Olin Library, Rollins College, Winter Park, Florida.)

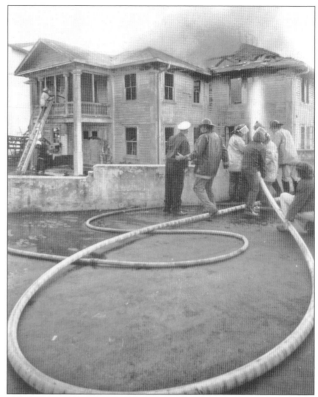

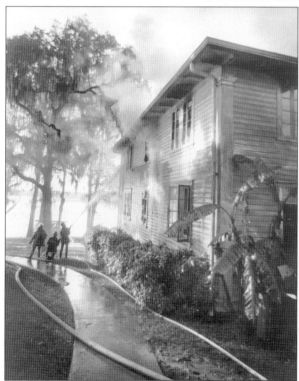

Because the building at Rollins College was being used as a theater workshop briefly in 1974, there were scenery, paint, lacquer, and power tools littering the area. In the rear of the building there were Freon, oxygen, and acetylene stored in the workshop for heating and air conditioning, creating volatile conditions for firefighters. (Department of College Archives and Special Collections, Olin Library, Rollins College, Winter Park, Florida.)

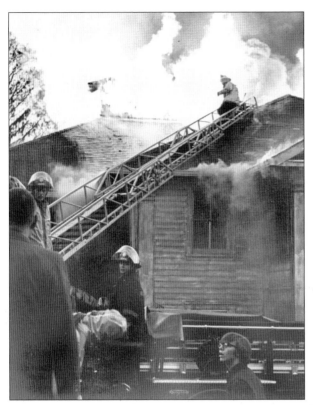

Firefighters from multiple departments worked from 7:55 a.m. until 9:30 a.m. and remained at Rollins College all day because flames kept igniting on the roof. Two pumpers sprayed 1,000 gallons of water a minute, but a gift to the college, the Blackman fireplace stretching from floor to ceiling, could not be saved in 1974. (Department of College Archives and Special Collections, Olin Library, Rollins College, Winter Park, Florida.)

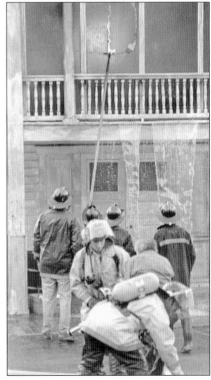

Despite the crumbling structure at Rollins College, no one was hurt in the fire of 1974 as members from different fire departments worked side by side. The building, regrettably, was beyond repair. While the true cause of the fire is not known, it was believed to have started on the second floor. (Department of College Archives and Special Collections, Olin Library, Rollins College, Winter Park, Florida.)

## Six

# THRILL THROWERS AND FIRE FIENDS

The first of a series of fires with similar characteristics was set on August 28, 1915, at the Whittenberg house. When successive fires of unknown origin in the same style appeared, the *Morning Sentinel* newspaper dubbed the culprit the "Fire Fiend." Around this same time period, concerned citizen C. W. Mathison wrote a letter to warn the public about a series of arsons in the Oviedo, Florida, area. After discussing the psychology behind such acts, he termed the culprits "Thrill Throwers" because of the intrinsic rewards these criminals felt after successfully setting fires.

However, such tactics hit even closer to the Orlando Fire Department in the 1900s, when it was illegal to sell alcohol outside saloons in Orlando. Fire Chief W. M. Mathews decided to open two saloons downtown. Shortly afterward, two other competing saloons opened up along the same boardwalk. This strip of Church Street accumulated loitering drunks who were arrested by police three or four times nightly. As a result, a "Wet and Dry" election was held in 1907 because so many residents disapproved of the saloon activity. A speaker's platform was set up across from the courthouse. Those who were on the side of the "Wets" hired a Tampa lawyer to speak on their behalf while the "Dry" side of the issue convinced Rev. Seaborn Wright from Georgia to plead their cause. The Dry faction won by merely two votes, but the dispute did not end there.

Twenty minutes after the results were announced on election day, fire alarm bells rang. When the volunteer fire department rushed to the fire, the horses wildly ran in the opposite direction, refusing to change course until reaching Marks Street. When finally turned in the right direction, the horses would not stop, running through the blazing saloon belonging to W. M. Mathews. Both of Mathews's saloons and a livery stable burned to the ground. Fannie the horse was severely singed, but the driver was uninjured. James H. Barton, the oldest Orlandoan (born in 1877), claimed that someone broke into the fire station and crossed the horses' reins, causing the delay in reaching the fire.

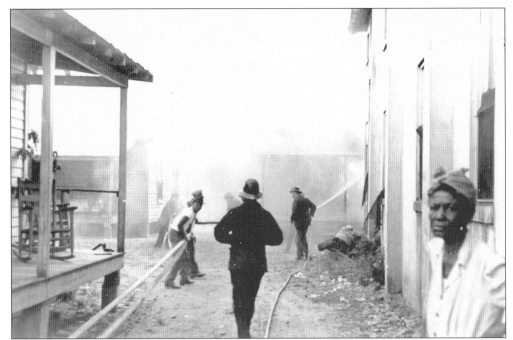

Christmas Eve celebrations were halted in 1944 because of fire on Conley Street. The first reported fire injury in Orlando originated from a 1850s holiday prank. When an intoxicated gentleman passed out, local youth tried to trick him into believing he was in Hades by building a fire around him. The victim's coat caught on fire, but he only received minor burns. (Lt. Earl D. Horst Collection.)

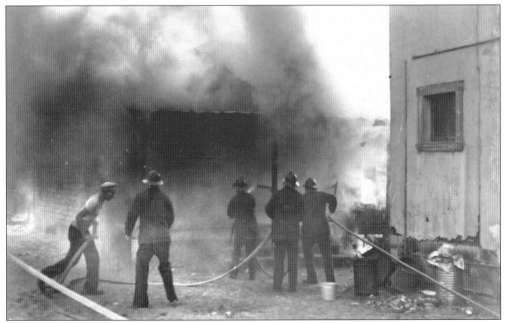

As seen in the December 24, 1944, fire on Conley Street, firefighters wore helmets during this time period called "War Babies." The helmets were given this name because this style of protective gear was issued for the first time during World War II. (Lt. Earl D. Horst Collection.)

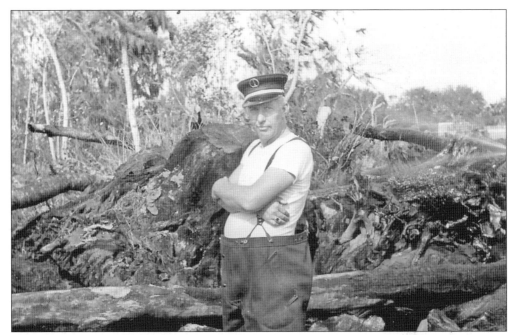

In 1946, Lt. E. D. Horst stands before a dump fire that he and his men were able to bring under control. That same year, Lieutenant Horst called all of the fire department's equipment to the J. C. Lewis Trucking and Capping Service plant at 11:41 p.m., where they worked until 5:45 a.m. Due to the burning rubber, thick black smoke blanketed the area. (Lt. Earl D. Horst Collection.)

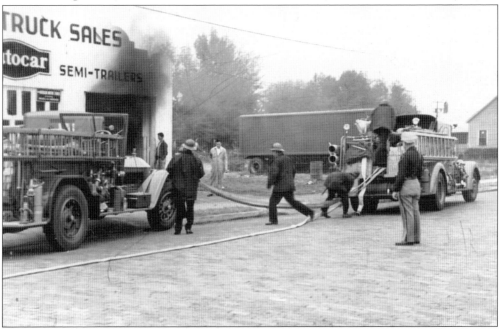

This garage fire around 1947 caught the attention of onlookers on West Church Street. However, the turnout paled in comparison to the 30,000 people who gathered in 1940 to watch the fire within the Security Feed and Seed Company spread to the Falls City Beer Distributors within the building owned by Atlantic Coast Line Railroad. (Lt. Earl D. Horst Collection.)

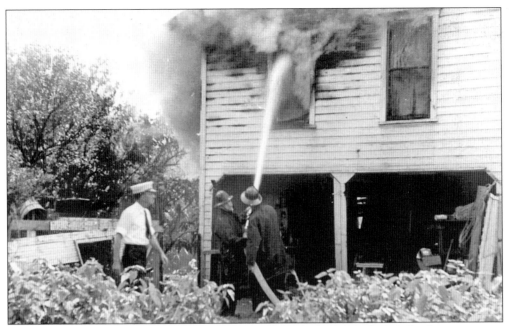

Assistant Chief Loy Davis (left) oversees his men during a fire around 1948. By this time, most fears associated with water pressure were eliminated. But in 1899, firefighters relied on the Orlando Water and Light Company and its 100-foot-high standpipe on Marks Street to maintain water pressure. Otherwise, there were only two small pumps to feed the city's needs. (Lt. Earl D. Horst Collection.)

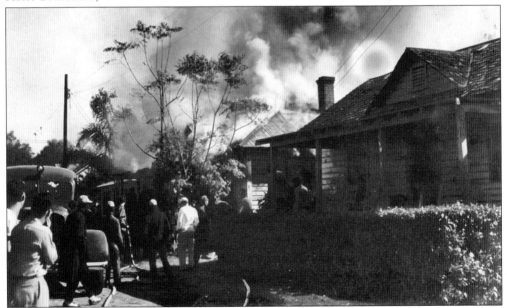

Station Two responded to this Callahan Drive fire in 1949. Much like the 1868 courthouse fire, the cause was unknown. However, when the courthouse was burned down in 1868, the fire was most likely set to destroy evidence inside that could incriminate the arsonists. Inside the two-story log courthouse, all books were destroyed in the fire, so records of Orange County begin in 1869. (Lt. Earl D. Horst Collection.)

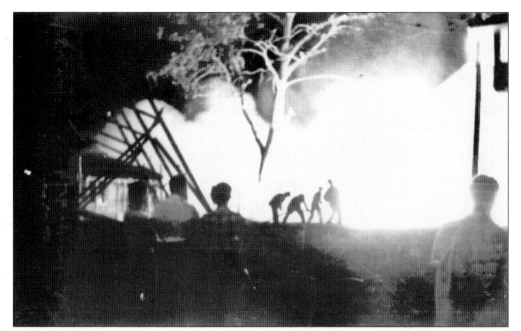

When firefighters arrived on the scene of the May 30, 1951 fire, flames towered above them, causing onlookers to wonder how anyone could possibly contain the approaching wall of combustion. It is likely that the fire was started by sparks emitted from trains when traveling the rails or switching tracks along the parched grasses. (Lt. Earl D. Horst Collection.)

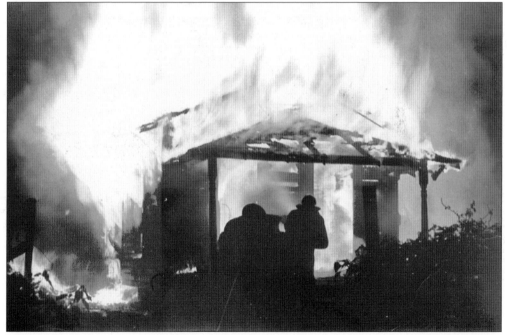

This Jerrigan Street fire around 1954 erupted at the same time that there were 60 firefighters working for the Orlando Fire Department. During this year, the fire chief's salary was raised to $460 a month. Other titles in the department followed suit with raises shortly afterwards. (Lt. Earl D. Horst Collection.)

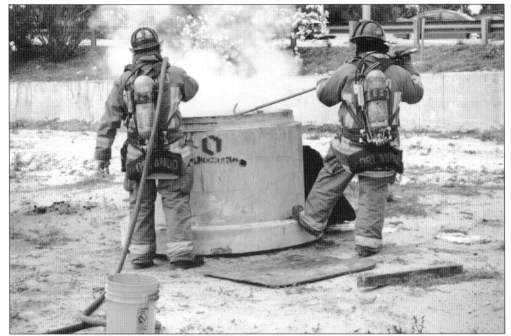

Firefighter Neal Yochim (left) and Pierre Nixon quickly contain a mysterious fire that erupted on a construction site. Those detained in five o'clock traffic on Interstate 4 in the background were able to watch the skilled men quickly subdue the flames before smoke spread across the highway. (Ginger Bryant.)

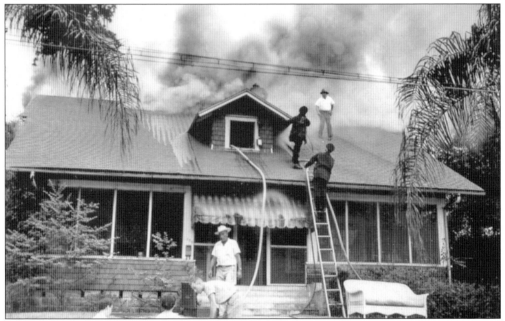

During the late 1950s, Station Three's men work against this College Park fire. Lt. Walter Tedder casually walks down the wet roof without the aid of firefighting boots as firefighters attack the flames beneath him in the attic fire. Lieutenant Tedder was known for being as comfortable at precarious heights as he was on solid ground. (Orlando Fire Department Archives.)

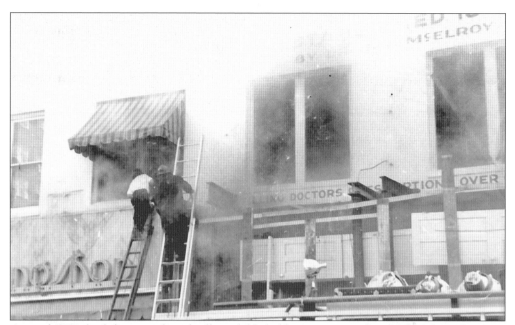

Around 1957, firefighters work with all available ladders to put out the McElroy fire. The scene was unlike the 1912 Wyoming Hotel fire, in which guests helped pour buckets of water out the windows and down the sides of the building to prevent the spread of sparks. During the downtown McElroy fire, firefighters worked alone. (Lt. Earl D. Horst Collection.)

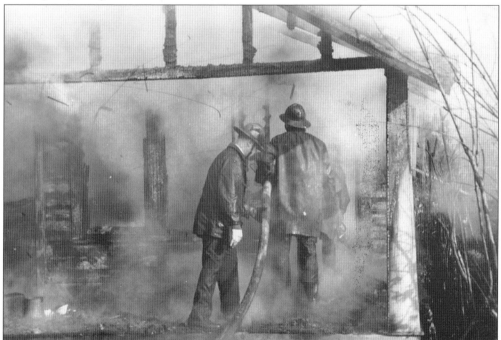

Firefighters C. L. Cox (left) and Oates worked together on a fire around 1956 until there was little structure remaining beyond the building's frame. This year the Orlando Fire Department traveled 3,014 miles in order to answer 713 calls throughout the year. Of the calls, 359 hours' worth of service were devoted to battling fires. (Lt. Earl D. Horst Collection.)

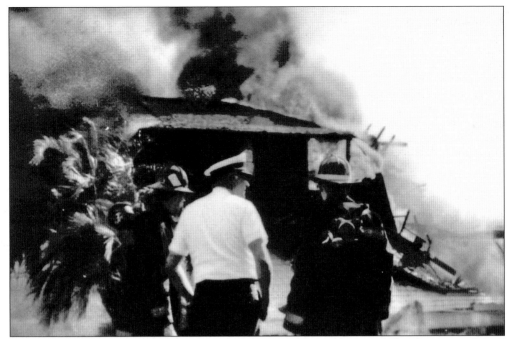

Firefighters often battle flames during the adverse weather conditions of Florida, as seen during the 1960s. Circumstances were no different in 1903, when the Burden's Arcade Hotel caught fire. A hurricane was blowing in from the west, and lit shingles from the roof were sent high into the air, only to be put out when landing in Lake Eola. (Orlando Fire Department Archives.)

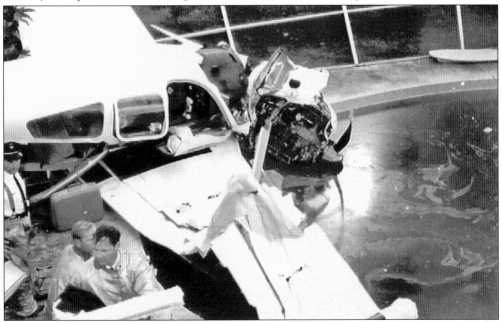

At 1:39 p.m., residents less than a half mile from the Herndon Airport runway were in for a surprise when they found a small aircraft on the patio next to their enclosed swimming pool. Firefighters rushed to the scene in 1971 to provide rescue efforts amongst the wreckage. No one in the home was injured. (Orlando Fire Department Archives.)

In the early morning hours of 1971, both fire and police responded to the beginning of a series of mailbox fires. The first took place on East South Street and was regarded as a federal offense, because U.S. mail was being tampered with and destroyed. (Orlando Fire Department Archives.)

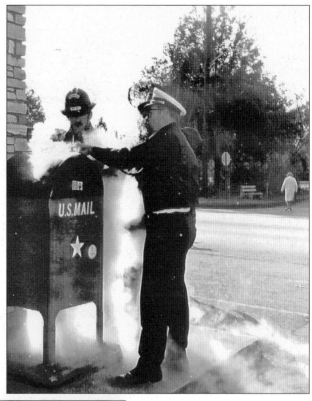

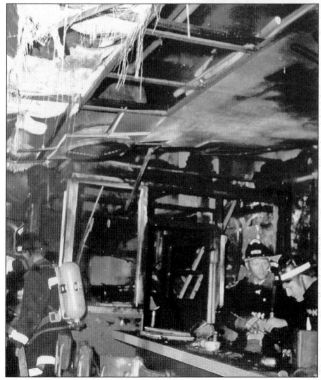

On March 20, 1971, a 9:44 p.m. call prompted the fire department to respond to a large fire already in progress. Here firefighters inspect the remaining clues behind the counter area of the Lovis Restaurant. While the fire likely started in the kitchen, other portions of the establishment hit hardest by flames were also scoured for anything that could reveal the point of origin. (Orlando Fire Department Archives.)

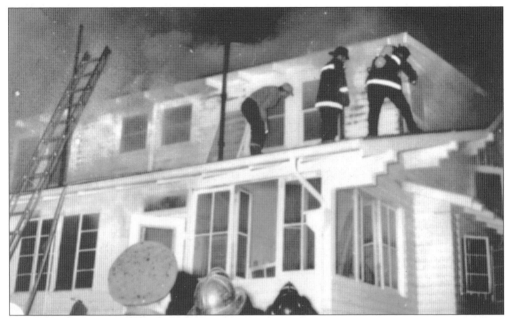

At 12:37 a.m., firefighters were called downtown to East Wall Street in 1971. Though fortunately unoccupied at the time, a fire was in progress in the office and nursery areas of a church. Search and rescue procedures were carried out to ensure that the building was unoccupied despite the early morning hour. (Orlando Fire Department Archives.)

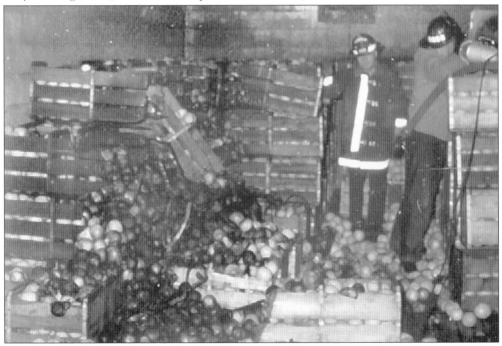

Loss of any type is regrettable, but for the distributors of citrus who lost a large portion of their crop in 1971, the West Robinson Street fire was particularly devastating. Firefighters sifted through crates of outgoing oranges, but there was nothing left that would be fit for human consumption. (Orlando Fire Department Archives.)

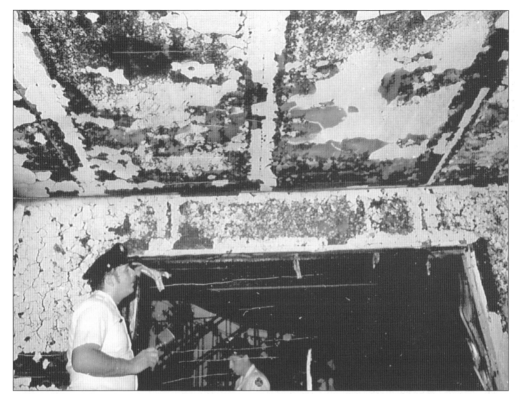

After a November 6, 1971, apartment fire, peeling paint was all that could be seen in the gutted rooms. This devastation from sheer heat was also seen during a 1940 fire, when an outdoor trash can's metal bottom melted and fell to the ground. When cases of beer exploded in the 1940 fire, the windows in the building across the street cracked. (Orlando Fire Department Archives.)

Interstate 4 is the main thoroughfare for Orlando, creating congestion and ample opportunities for accidents at high speeds. On August 14, 1972, the Orlando Fire Department was utilized to extinguish flames before hazardous materials produced explosive results. Everything was contained around 1:21 p.m., before rush-hour traffic became involved. (Orlando Fire Department Archives.)

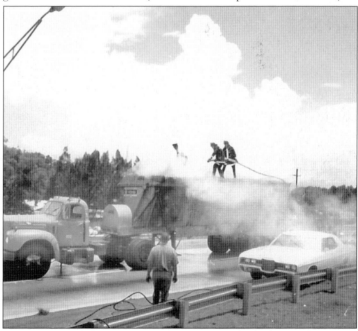

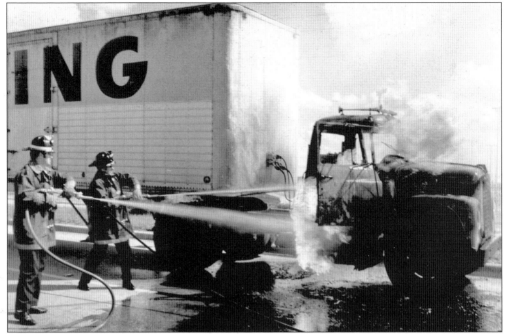

On October 25, 1974, Interstate 4 was the location for a fire that erupted in an 18-wheeler, requiring intervention from fire and rescue. In 1914, when the year was examined in review, there were 17 alarms of fire during the past 12 months with no serious threats posed by any of the emergencies. The firefighters of that era never could have imagined the challenges of the present day. (Bob Cross.)

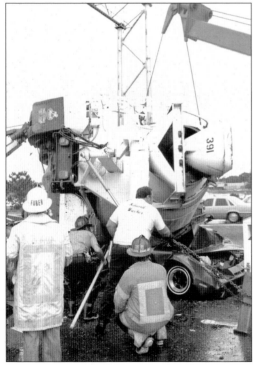

At the exit of Interstate 4 on Ivanhoe Boulevard, there were miraculously only minor injuries on the scene when a cement mixer toppled onto a car. The driver of the vehicle was contained in the only portion of the car that was not crushed under the weight of the lost cargo. (Bob Cross.)

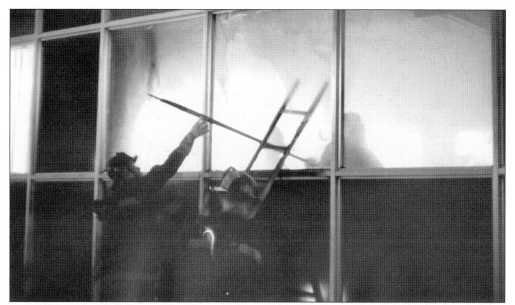

Around 1970, a Molotov cocktail was thrown through the window of the Social Security Administration building. Just one floor up, records for the draft were housed during this somewhat tumultuous period of history. Engine Three was called to the scene, and firefighters can be seen working with a pike pole. (Camnitz Collection.)

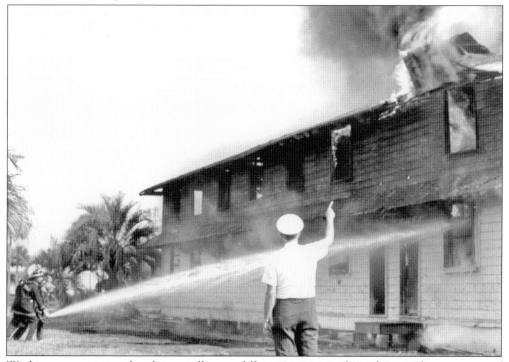

Working as a unit involves being willing to follow instructions from those with more years of experience. This mentality is stressed from the beginning of a firefighter's training at the fire academy. During the 1970s, firefighters shown receive advice on the quickest way to knock down this two-story fire. (Camnitz Collection.)

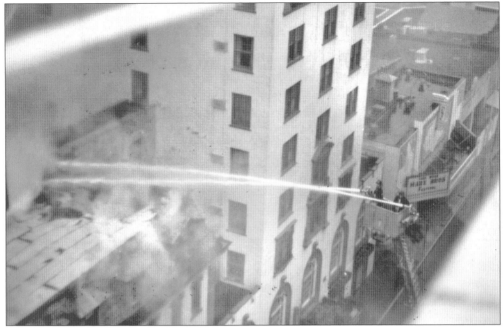

On January 2, 1979, the San Juan Hotel caught on fire. While there were holes already cut in the upper floors of the building in preparation for demolition, the bottom levels of the building were still inhabited. Due to the unsafe conditions in the building, firefighters fought from the exterior, using 1,500 gallons of pressure from Tower One. (Chief Randy Tuten Family Collection.)

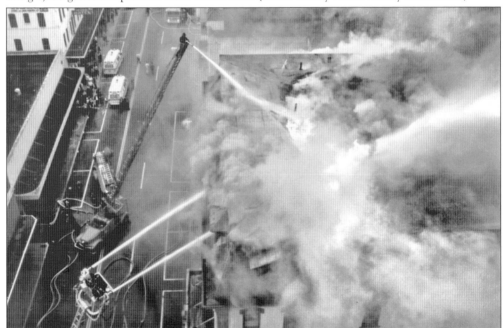

During the 1979 San Juan Hotel fire, 100 firefighters, three towers, five engines, and 6,770 feet of hose were utilized. The firefighters worked quickly, because the top three floors were already engulfed in flames upon arrival. The total estimated loss was $250,000, but no one was injured. (Bob Cross.)

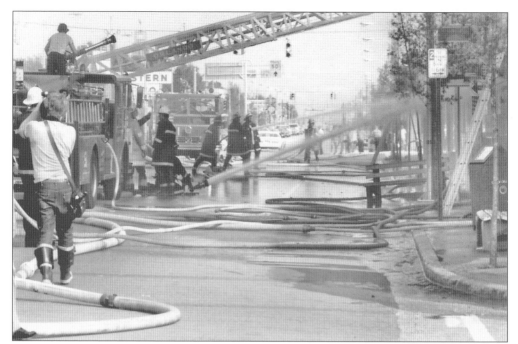

On November 10, 1979, there was an involved fire on the corner of Highway 17-92 and Colonial Drive. The damage encompassed multiple stores in the 110–112 block of a business and shopping district. Three towers, six Seagrave pumpers, and 1,200 feet of hose were used on site. (Chief Randy Tuten Family Collection.)

In 1983, the 11th-floor ballroom of the Angebilt Hotel caught on fire. Firefighters had to walk up the many flights of stairs because water drained down through the elevator shaft. The fire was not venting itself, and the wind kept blowing flames back inside the building. (Bob Cross.)

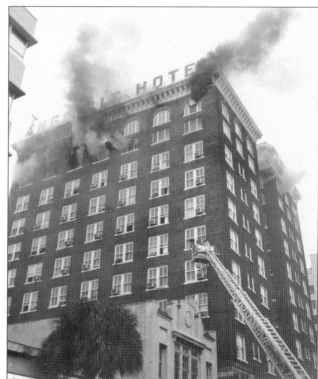

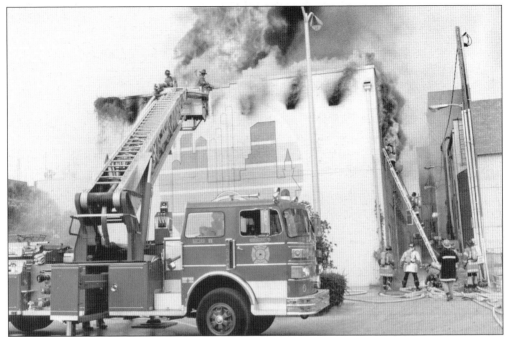

On July 26, 1983, the Carey Hand Funeral Home caught on fire after repairs were made to the flue above the crematorium. After changes were made to the exhaust system over the weekend, Monday's cremation session caused flames to spread unnaturally, igniting the building. At first, smoke went undetected because of the nature of typical operations on property. (Bob Cross.)

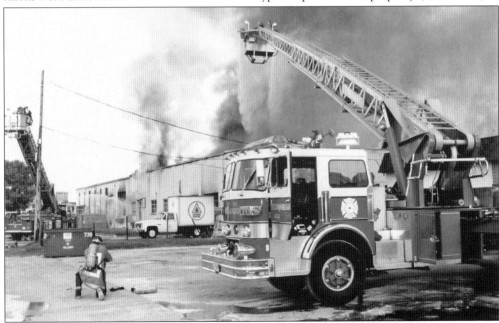

On May 21, 1988, the Atkins Paper Company and Hinley Air Products warehouse caught on fire, causing occupants to rely on the Orlando Fire Department to save its wares. Since 1975, the department has established a paramedic program, enabling firefighters to respond to all needs on-scene. (Bob Cross.)

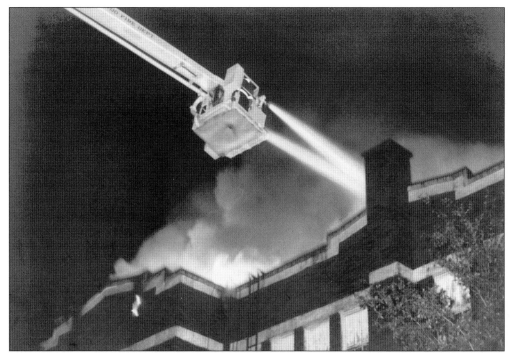

A large fire spread quickly throughout the Orange County Health Department around 1991. Snorkel Two was used so that firefighters could easily change their attack on the flames from above as needed. The apparatus's articulating arm provides ease of mobility and best access to the fire. (Camnitz Collection.)

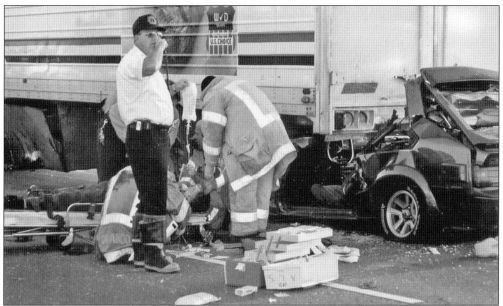

An emergency tracheotomy was performed in the field around 1991 when an 18-wheeler stopped short in traffic, and a car drove under it. Not realizing that traffic had come to a halt, the driver was unable to stop prior to collision. Chief Randy Tuten makes a call on his radio for further assistance at the scene. (Chief Randy Tuten Family Collection.)

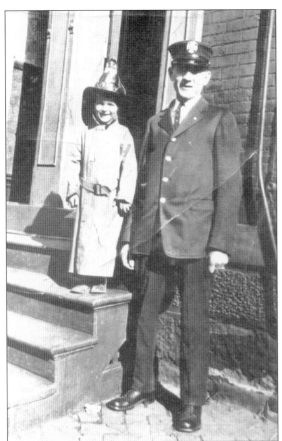

Most every little boy dreams of being a firefighter, and Larry Camnitz (left) was no different. Playing dress-up was more like practice for his future career when he donned the gear of his father (right), who was devoted to fire service, around 1927. Firefighting became part of their family's traditions. (Camnitz Collection.)

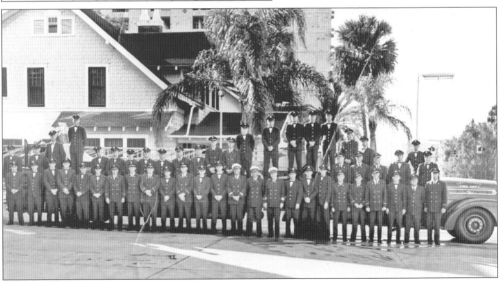

The entire Orlando Fire Department gathered for what they termed a family portrait around 1960. Admired and heralded by all, even the Salvation Army gave the firefighters coffee and doughnuts after they extinguished large, lengthy fires at various locations. The entire community welcomed the heroes wherever they went. (Chief Randy Tuten Family Collection.)

# Seven

# LOCAL FAVORITES AND WORLD-FAMOUS FACES

There have been many faces that have shaped the fabric of the Orlando Fire Department throughout the years, and that talent has attracted the attention of notables from around the world. After leading the department from its creation in 1885, the first fire chief, John W. Weeks, resigned on April 14, 1888, so that he could return to Massachusetts, where he became a senator and ultimately a secretary of war for both the Coolidge and Harding cabinets. Following in his footsteps, the second fire chief, William C. Sherman, opened the first jewelry store in the area and raised $2,000 so that a clock could be added to the tower of the first brick courthouse in 1892.

The third fire chief, John W. Gettier, began his career with the department in 1893. However, Gettier resigned from his position with the fire department during some turmoil and unexplainable events. On the same day as Gettier's resignation on May 12, 1896, Dr. L. W. Pilley, secretary for the department for three years, also resigned. A month later, on June 16, within the last moments of a meeting, First Assistant Chief Engineer William Smith resigned as well. Within a two-month period, the top officers of the department resigned without providing rationale for their decisions. Minutes simply indicate that there was much bickering amongst members. Gettier was reinstated to the position of fire chief until 1904 and eventually passed away in 1913.

William M. Mathews served as the fourth fire chief from 1904 until 1907. Mathews left his position as fire chief in Orlando when his stable and saloons were burned to the ground, and he took a position in the Tampa Fire Department as fire chief. Mathews died tragically when his Cadillac collided with an aerial truck in Tampa. Mathews had a habit of standing in his car while it was in motion, and this caused him to lose his life when his own firefighters hit his vehicle. These founding fathers of the Orlando Fire Department paved the way for the leaders who are still battling the fire fields.

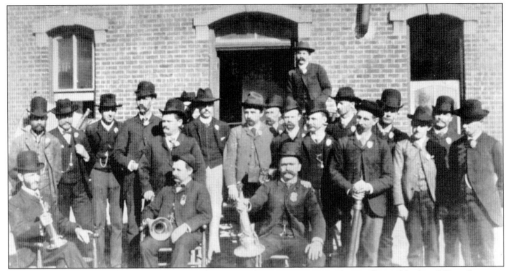

William C. Sherman (seated second from left with a speaker trumpet) was elected by his fellow firemen to be the second official fire chief. Additionally, he was the founder of the volunteer company for Orlando. Sherman lived to be 92 years old and served as fire chief until 1892. At that time, he served as the chairman of the Winter Fair Association. (Chief Randy Tuten Family Collection.)

Chief William Dean, Orlando's fifth fire chief, made arrangements for all of the water plugs in Orlando to be painted white as of December 10, 1914. Merely nine days later, the Orlando Water and Light Company followed the paint job with a new paint scheme. Almost in defiance of recent commands, all plugs were painted red with silver tops. (Chief Randy Tuten Family Collection.)

Chief William Dean was replaced by his son, Gideon Dean, in 1936. As a child, Joseph S. Guernsey saw Gideon Dean and recalled, "Seeing Gideon in his uniform . . . he was rather an awesome fellow to us kids in those days." Around 1885, a Badger fire bucket was given to townspeople for firefighting. Buckets had a rounded bottom to prevent other forms of usage. (Chief Randy Tuten Family Collection.)

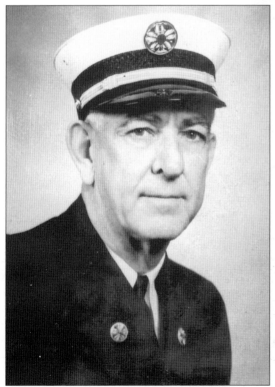

Maxie G. Bennett served as the seventh fire chief until 1949, when he was returned to the title of lieutenant. Assistant Chief Loy Davis served as acting fire chief for three years but was never made an official fire chief. A native to Orlando, Bennett left the area to serve in World War I with the 101st Infantry Division in France. (Chief Randy Tuten Family Collection.)

In 1953, Paul Pennington became fire chief. With formal school through the eighth grade, Pennington was so determined to finish his education that he received his diploma 25 years after he joined the department. After 42 years of fire service, Pennington retired and became fire chief of the Reedy Creek Improvement District Fire Department, the first fire department at Walt Disney World. (Chief Randy Tuten Family Collection.)

During a retirement ceremony, from left to right, Fire Chief Paul Pennington and Rudy Owen honor Lt. E. D. Horst and Hugh Minick around 1960. While Paul Pennington was fire chief, insurance rates decreased for citizens when the National Board of Fire Underwriters changed Orlando's fire rating to a more favorable status. Pennington was given the title Fire Chief Emeritus of OFD. (Lt. Earl D. Horst Collection.)

Melvin Rivenbark served as the ninth fire chief from 1968 until 1973. During the five years that Rivenbark served as fire chief, Fire Stations 3, 7, 8, 9, and 10 were built. Orlando's first binding sprinkler ordinance was passed, and the firefighters' union was established. (Chief Randy Tuten Family Collection.)

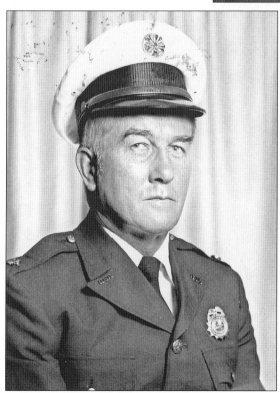

Pulled from the position of deputy fire chief during Chief Rivenbark's administration into the title of fire chief in 1973, Charles S. Parker was credited with heading the most growth in the shortest span of time since the fire department's existence. Advancements with computers and communication systems were also made until Parker's retirement in 1977. (Chief Randy Tuten Family Collection.)

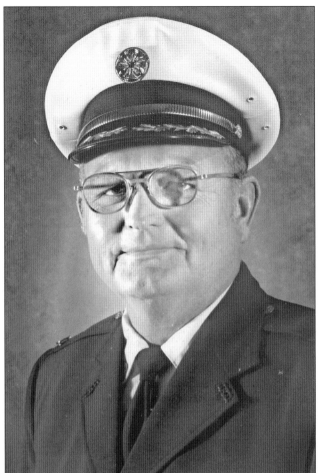

Francis E. "Gene" Reynolds became fire chief in 1977, but his firefighting career began in 1954. He brought about changes so that all firefighters below the rank of captain had to become certified emergency medical technicians. Reynolds was the first to employ females, establish a joint response agreement with the Orange County fire departments, and implement the National Fire Incident Reporting System. (Chief Randy Tuten Family Collection.)

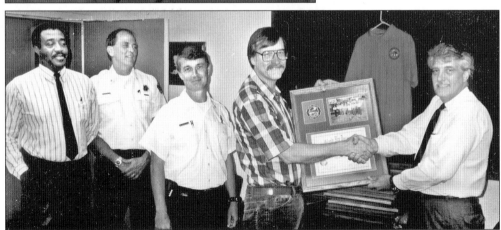

When Charlie Lewis became fire chief in 1989, he started a wellness program for members of OFD and started an emergency medical dispatcher system. Following him is the 13th fire chief, Robert A. Bowman (far right). From left to right, Chief Walker, along with Chief Alan MacAllaster, Chief Glenn Kinnear, OFD historian Dick Camnitz, and Chief Bowman gather after Camnitz completed Citizens' Fire Academy around 1996. (Camnitz Collection.)

When Donald W. Harkins became fire chief in 1996, he already had 25 years of experience in the fire service and had served as fire chief in other areas. Charlie B. Walker (pictured) was the first African American to serve as fire chief in 2000. He began his career in 1966, when he joined the Fire Service Unit of the Air Force. (Orlando Fire Department Archives.)

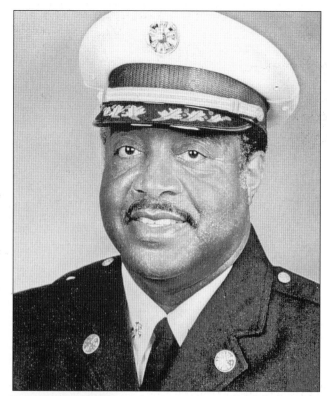

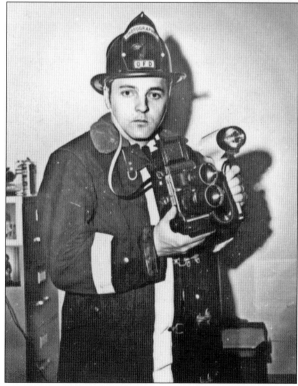

Weston J. Ault, around 1970, was the Orlando Fire Department's full-time photographer during the 1960s and early 1970s. He was on scene chronicling the major events of the department and even documented crime scenes in his compelling photojournalistic work. Outfitted in standard firefighting gear, he ventured where other firefighters worked under hazardous conditions but without their firefighting tools. (Orlando Fire Department Archives.)

One of the most anticipated events of the year was, and still is, the fireman's ball, known also as the "Fireball." Larry Camnitz (standing, left) and George Tuten (standing, right) took advantage of the annual social event to mingle with fellow firefighters and their elegantly dressed escorts around 1948. (Camnitz Collection.)

In the early 1950s, firefighters were invited to the policeman's ball. At this point in history, the Orlando Fire Department and Orlando Police Department were small enough to still mingle for social events. From left to right, Clara and Walt Sacsi, along with Gladys and Larry Camnitz, represented the Orlando Fire Department in this cluster. (Camnitz Collection.)

After a June 23, 1948, deep-sea fishing expedition, firefighters proudly returned to the station to boast about the sea turtle they managed to catch. From left to right, Walter Tedder, Gus Cooper, and Mel Rivenbark showed their trophy piece to fellow firefighters Dennis Pennington and Lt. Person Bailey. (Orlando Fire Department Archives.)

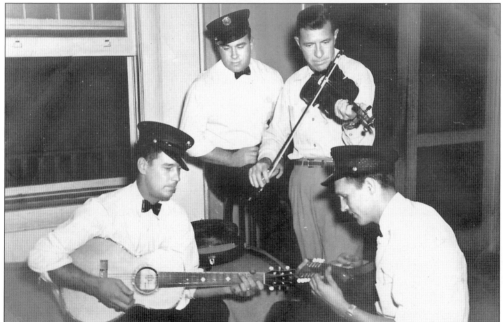

In the early 1950s, making music was a favorite way to pass the time between calls at the firehouse. From left to right, Clyde Ethridge, Pete Tillis, Rudy Owen, and Larry Camnitz find harmonies between sirens. Such band rehearsals helped firefighters relax in the few quiet moments they were given. (Camnitz Collection.)

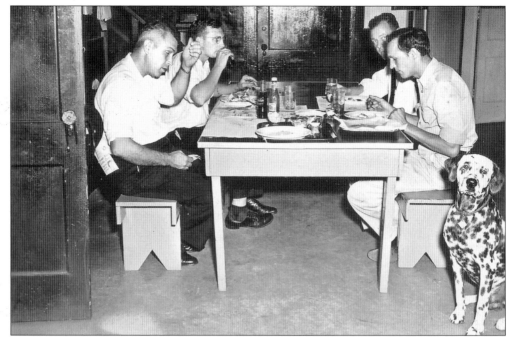

One of the favorite activities for any firefighter is pausing to have an evening meal next to the bays. On September 3, 1948, from left to right, Elbert Partin, Dick Cobb, Paul Pennington, Larry Camnitz, and Laddy refueled before jumping back on the rigs for the remainder of the shift. (Camnitz Collection.)

The dinner table is always a unifying element. In November 1991, members of Station 10 participated in the nightly ritual of birthday cake. If it is not a firefighter's birthday, everyone brings party hats out of their lockers, finds someone in the newspaper with a birthday on that date, and honors a stranger so cake can be served for dessert. (Chief Randy Tuten Family Collection.)

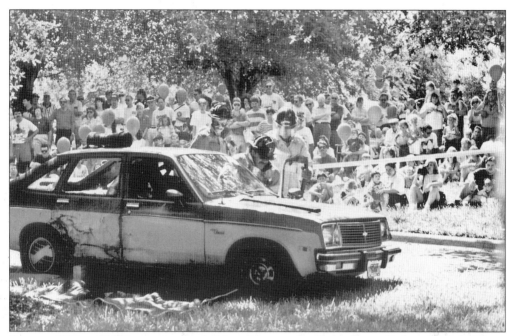

Between 1991 and 1996, musters were held on the grounds of Loch Haven Park in Orlando. These events would pull thousands from the community, because citizens were interested in watching this car extrication by OFD and other demonstrations of ability staged by firefighters. It was also a time for people to pose for pictures with OFD's fire apparatus on display. (Camnitz Collection.)

Actress Delta Burke (second from right) won OFD's Miss Flame title on October 13, 1972. Selected from 27 entrants, she received a $100 savings bond, red roses, crown, and trophy. Burke went on to win the title of State Miss Flame at the State Fireman's Convention and the Florida crown in the Miss America pageant. Her career in acting evolved from there. (Orlando Fire Department Archives.)

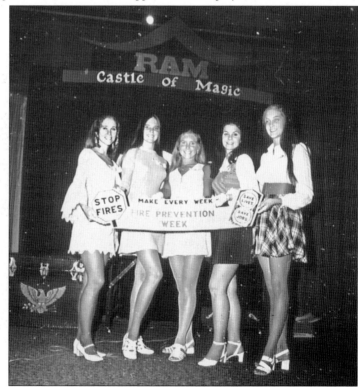

This 1956 Cadillac was temporarily parked at Station One during Pres. Lyndon B. Johnson's 1964 campaign. Known as the *Queen Mary II*, the vehicle was used by Dwight D. Eisenhower, John F. Kennedy, and Lyndon B. Johnson. It is equipped with a rifle rack, pistol holders, red light, siren, phones, and even secret compartments for ammunition. (Camnitz Collection.)

Housed safely within the bay of Station One, the *Queen Mary II* was a prized possession that traveled directly behind President Kennedy's car the day he was assassinated. At the time, it was being used to transport Secret Service and Vice President Johnson. The vehicle is capable of traveling 115 miles an hour, is 21 feet long, and weighs 7,000 pounds. (Camnitz Collection.)

Fire buff Arthur Fielder (right), conductor of the Boston Pops Orchestra in 1975, was invited by Larry Camnitz to board the Orlando Fire Department's apparatus. Fiedler was enthusiastic about his visit to the firehouse because of his interest in the field of firefighting. Correspondence continued between Camnitz and Fiedler after the conductor returned to Boston. (Camnitz Collection.)

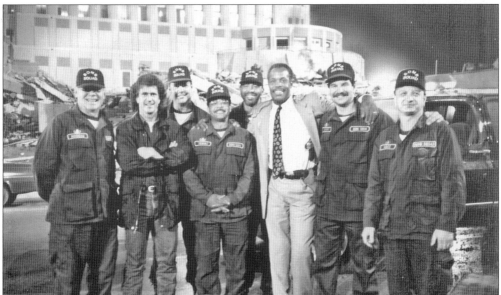

From left to right, Mayor Bill Frederick, actor Mel Gibson, District Chief Anthony W. Coschignano, District Chief Eullas Brinson Jr., a stunt man, actor Danny Glover, Lt. John R. Hackett, and Laurie Fraser gathered in front of city hall before it was imploded for the *Lethal Weapon III* movie on October 24, 1991. The Orlando arson and bomb squad was on hand to assist the movie studio with the demolition. (Chief Randy Tuten Family Collection.)

The loss of Roger "Deke" Coram was deeply felt by his fellow firefighters when he lost his life at the intersection of Livingston Street and Summerlin Avenue in 1944. Coram was the first firefighter in the Orlando Fire Department to be killed in the line of duty. Other fallen firefighters were remembered at Medal Day 2006, when their helmets were reverently placed together during "Last Call." (Ginger Bryant.)

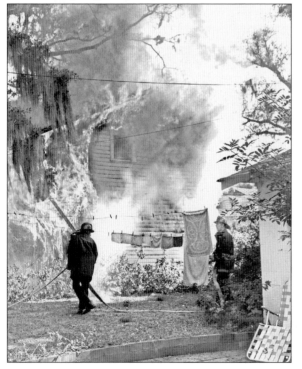

This neighborhood fire around 1969 threatened houses on all four sides because its two-story flames seemed uncontrollable. Probationary firefighter John A. Lewkowicz (left) and Bob Cross worked together to run hose lines not long before Lewkowicz's untimely death, which deeply saddened the entire firefighting community. (Camnitz Collection.)

# *Eight*

# FALLEN BUT
# NEVER FAR FROM MIND

The memory of those who have given the supreme sacrifice for others in need will always be honored by fellow firefighters and the public that is so indebted to them. In the centennial message entitled "A Century of Service," the Orlando Fire Department describes these heroes as "courageous fallen comrades who lost their lives answering the last alarm in unselfish and dedicated service to the citizens of Orlando." In today's world of carcinogenic fumes and hazardous chemical combinations that result from burning materials, there are progressively more line-of-duty losses due to health complications after fighting a fire. Those brave men and women put their own personal safety on the line daily, risking exposure to unsafe by-products of live burns. Those who gave their lives while on call include Firefighter First Class Roger "Deke" Coram, Probationary Firefighter John A. Lewkowicz, and Assistant Chief Calvin Bookhardt.

Engineer Roger Coram was navigating Fire Company One's engine through traffic in 1944 when he collided with a Pontiac sedan at an intersection. The car was hit behind its front fender, sending the car careening 116 feet from the point of impact. Fireman Coram passed away seven hours later from internal injuries. Three other firefighters aboard the engine were hospitalized for serious injuries, including a broken back, chest injuries, and deep cuts on extremities. After striking the sedan, the engine jumped a curb, sending firefighters into the air, and plowed into an oak tree. Injured firefighters were still on the ground when their chief, Maxie Bennett, arrived. It was the worst wreck in the history of the department at that time.

On February 10, 1969, firefighter John Lewkowicz had been serving for less than a year on probationary status when he was killed at age 29 on his way to a fire. He was a plugman riding on the tailboard of the apparatus at the time of the accident. Seven others were injured when a flatbed truck loaded with two pieces of heavy equipment hit and overturned the fire truck on Parramore Avenue. Herman Clark was driving the fire apparatus at the time.

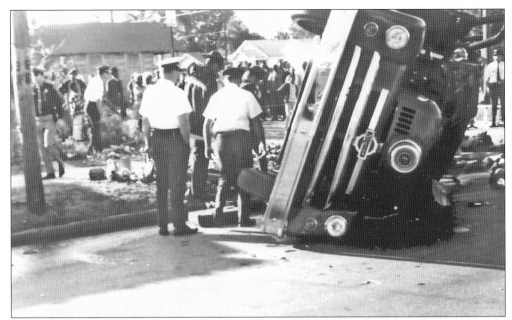

At 4:20 p.m. in February 1969, a fire truck was responding to a house-fire call when tragedy struck. A contracting truck hit the fire apparatus in its side at the blind intersection of Parramore Avenue and South Street. It was later discovered that the house fire was nothing more than a burning pot on a stove. (Camnitz Collection.)

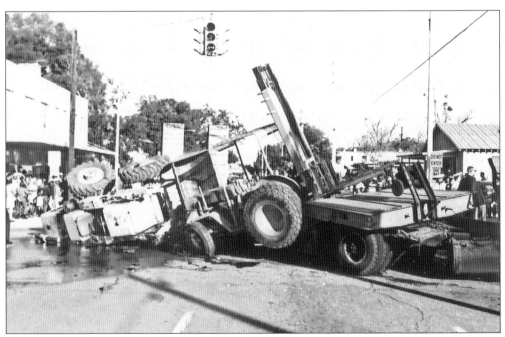

The contracting truck that hit the fire apparatus in 1969 was carrying a 3,000-pound forklift and an 8,000-pound end-loader. The collision happened so quickly that even a few bystanders had to be hospitalized because they could not get out of the way in time. (Camnitz Collection.)

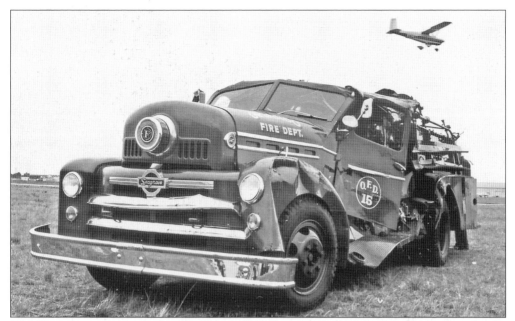

Folded hose lines were exposed, and equipment from Engine 15 littered the site of the 1969 crash. The front end of the contracting truck struck the engine, throwing John Lewkowicz from the tailboard upon the impact of the two trucks. Sacrifices such as his brought about changes in regulations so that firefighters no longer ride on the tailboards of apparatus. (Camnitz Collection.)

After the overturned engine cost John Lewkowicz his life, the City of Orlando took measures to memorialize this devoted firefighter's time with OFD and service to the community. In honor of the fallen firefighter, the street behind the Orlando Fire Museum is named John Lewkowicz Drive. (Camnitz Collection.)

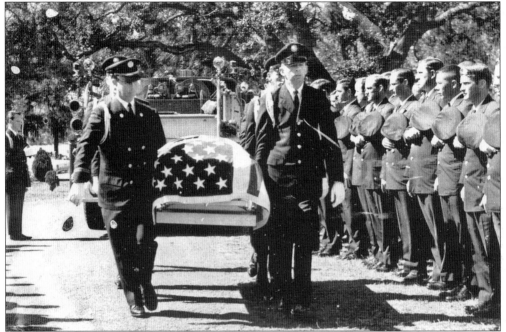

John Lewkowicz's funeral was attended by his fellow firefighters at Station Two, along with the other brothers in fire from the department. Never willing to forget the past or those who paved the way before them, present-day firefighters have this framed image from 1969 prominently displayed at the station on Parramore Avenue. (Orlando Fire Department Archives.)

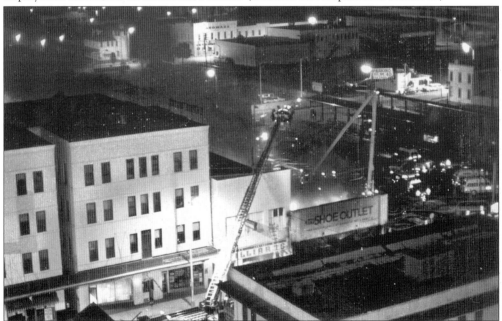

Calvin Bookhardt joined the Orlando Fire Department on July 15, 1955. On the night of December 2, 1972, his career was brought to an end in a large fire within a shoe outlet on West Central Boulevard. It was the third line-of-duty death for the department but the first on an actual fire scene. (Camnitz Collection.)

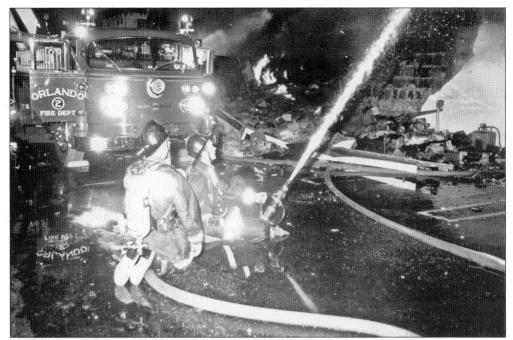

Assistant Chief Bookhardt was on the roof of the shoe outlet in 1972 performing ventilating procedures. He was standing next to a parapet when a backdraft caused an explosion, leading to the collapse of walls and the roof. Bookhardt fell down between the walls while other firefighters rode down on the roof. (Camnitz Collection.)

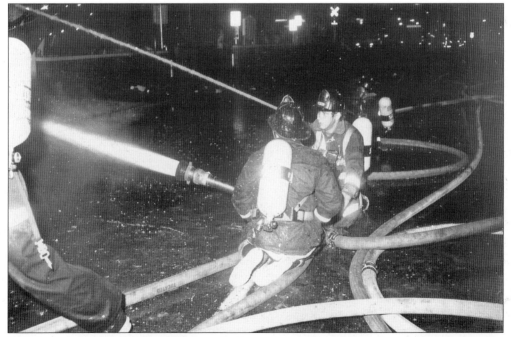

The fire was in full progress at 1:56 a.m. in December 1972, and firefighters had to work in the darkness, assisted by the glow of the flames. Throughout the event, 12 firefighters sustained major injuries, and Assistant Chief Bookhardt lost his life in the roof collapse. (Camnitz Collection.)

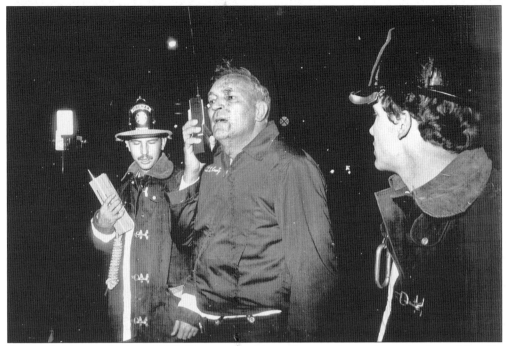

During the shoe outlet fire of 1972, Deputy Chief Larry Camnitz (center) remained near his radio in order to keep firefighters apprized of new developments moment-by-moment as the fire took on a personality of its own. Camnitz was on sick leave after back surgery the night of the fire, and it was Bookhardt who had replaced him that night. (Camnitz Collection.)

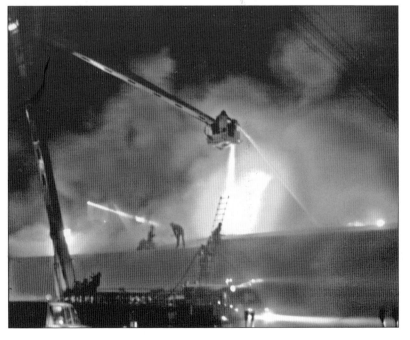

While fighting the shoe outlet fire of 1972, ladders were used in conjunction with the snorkel for optimum effect. Chief Bookhardt (center) can be seen on the roof moments before its collapse. Tragically, this was the last time he was seen working the fire site with his men. (Bob Cross.)

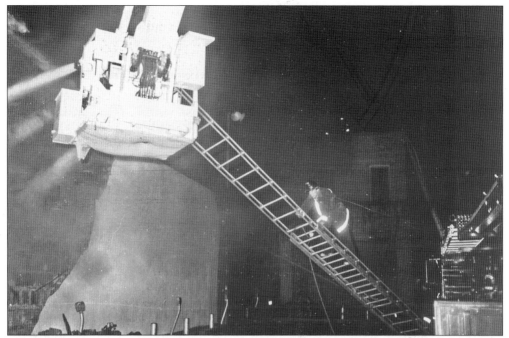

During the 1972 fire, Alan MacAllaster was ascending a ladder that was leaned against a wall of the ignited building. When the wall collapsed, he was catapulted completely over Snorkel Two and required hospitalization. Despite the distance MacAllaster was thrown from the building, he miraculously survived. (Camnitz Collection.)

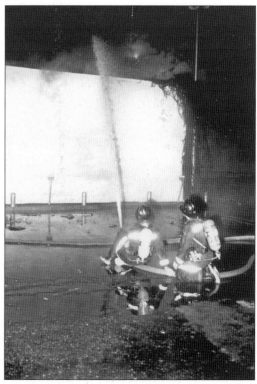

Even as the sun came up on the shoe outlet fire in 1972, firefighters were still making certain that the possibility of smoldering materials reigniting was extinguished. Those who were badly injured were receiving medical attention, but it was at this point that fellow company members discovered that Assistant Chief Bookhardt was not amongst them. (Camnitz Collection.)

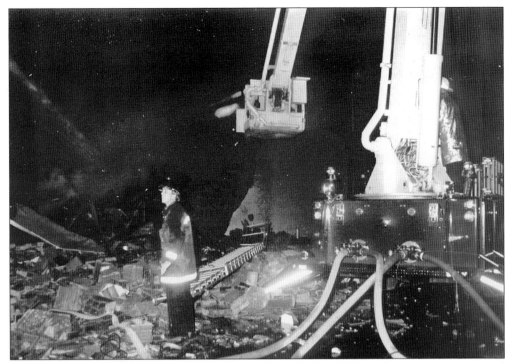

The main structure of the shoe outlet had to be demolished in 1972, and investigators reviewed all clues on site to try to discover the cause of the extensive fire. The true point of origin was never determined, and the building was never fully reconstructed. (Camnitz Collection.)

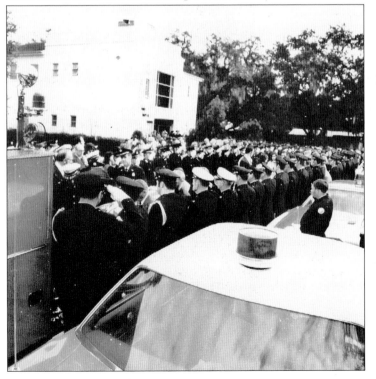

Firefighters surrounded Assistant Chief Bookhardt one last time at his 1972 funeral. He was the only firefighter who did not make it out of the shoe outlet fire. Later, on West Central Avenue, the Calvin Bookhardt Memorial Park was built to commemorate the life of a fallen hero. (Orlando Fire Department Archives.)

## Nine

# A NEW CENTURY
# OF SERVICE

At the approach of the new millennium, Fire Chief Charlie B. Walker took the reigns in 2000 with a focus on attracting minorities to the field of fire service. He made $183,000 worth of improvements to fire stations, built Station 13 and a temporary Station 14, and employed an infectious control officer. Additionally, the fire department took over the Orange County Historical Museum and opened it again as the Orlando Fire Museum.

Robert A. Bowman followed in Walker's footsteps as fire chief in 2003 and was the 16th fire chief for OFD. Previously Bowman served as fire chief from 1993 until 1996. Bowman became fire chief after working as a firefighter in Maryland and serving the Orlando Fire Department since 1971. During his service, he began the community emergency response team, the Neighborhood Emergency Training Program, Citizens' Fire Academy, and a program aimed at preschoolers entitled "Learn Not to Burn." Station 12 was opened under his direction, and a traffic preemption system was installed so that fire department apparatus could override traffic signals at major intersections, giving firefighters clear thoroughfares and faster response times.

In 2006, third-generation firefighter Jim M. Reynolds followed in the footsteps of his father, the 12th fire chief in the history of the department. Jim Reynolds began his career in 1984 and serves as the 17th fire chief for the Orlando Fire Department. Carrying out the traditions of the past, the Orlando Fire Department continues to meet the challenges of a growing metropolis, facing every new obstacle with pride in its past achievements and confidence in its future direction.

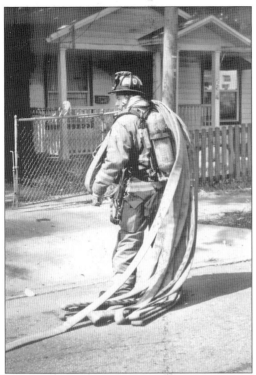

Neal Yochim begins laying lines on a fire scene during the summer of 2006. Upon arrival, the boarded up and supposedly abandoned house containing squatters only had a small amount of smoke seeping out beneath the eaves. However, once firefighters pried their way into the structure, it was like a pressure cooker under the tin roof, with temperature readings of 1,400 degrees at the ceiling. (Ginger Bryant.)

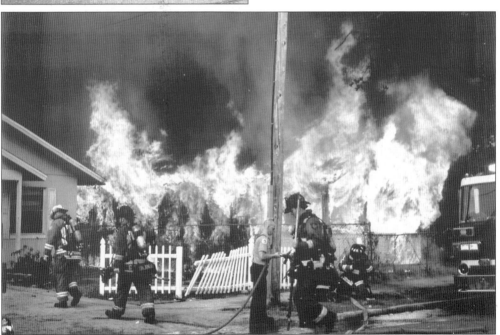

Firefighters from multiple houses were called in to respond to a 2006 house fire. Because the wooden structure was constructed from old pine, it literally turned to turpentine as its walls heated up, creating a more volatile environment. Even though the tree branches above the home were green, they also caught on fire, setting off explosions in transformers as power lines fell to the ground. (Ginger Bryant.)

In the midst of fighting a 2006 apartment complex fire, David Giovannini (right) shares the water-filled cooler with fellow Tower Two firefighter J. B. Harris. After a momentary pause to hydrate and get blood pressure checked, they returned to the blaze. That night five residents were pulled from the flames that had backed them into an inescapable corner. (Ginger Bryant.)

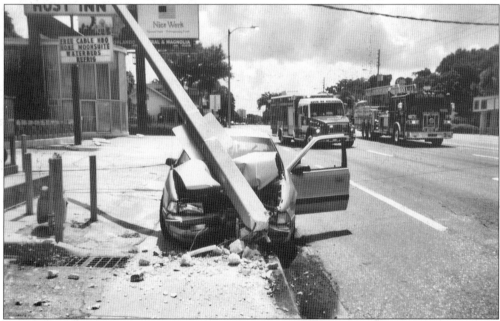

Rescue Two and Tower Two (right) arrive to assist with an accident in 2006. The driver careened into a light pole because of a decision to drive while intoxicated. Automotive accidents often involve extrications and fire containment in addition to the provision of medical services. (Firefighter Shawn Keith.)

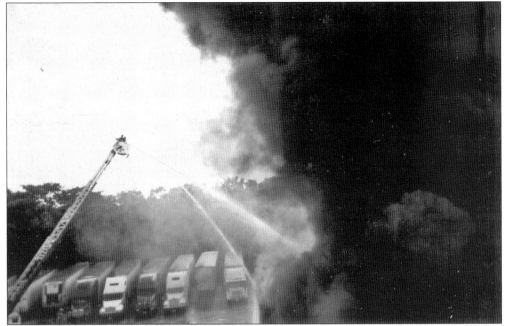

This photograph was taken from the vantage point of Tower Two on A Shift. Tower Nine attacks a warehouse fire from above as the flames try to spread throughout the 20,000-square-foot structure. A single plume of black smoke could be seen from miles away during this October 2006 fire. (Firefighter Shawn Keith.)

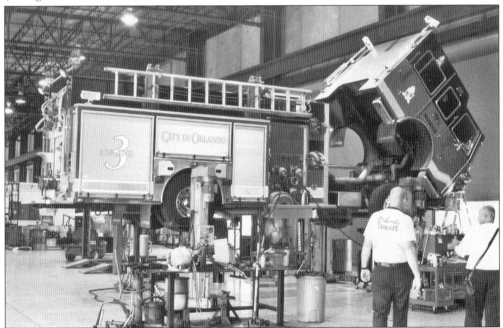

Ken Ireland (left) and Lt. Patrick E. Martin walk through the staff-and-line facility to check on the status of an out-of-commission piece of apparatus. Along the way, they talk to a mechanic about Engine Three, another piece of Sutphen apparatus that was on the rack receiving in-house repairs in 2006. (Ginger Bryant.)

Vehicles with entrapped people are not the only things that require the use of saws and other hand tools. Firefighter Eric Miller saws through metal bars, used by grocery stores and other retail outlets at night to guard against theft, in order to reach a fire. (Ginger Bryant.)

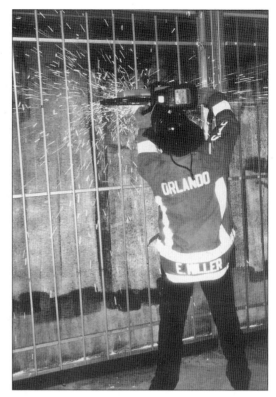

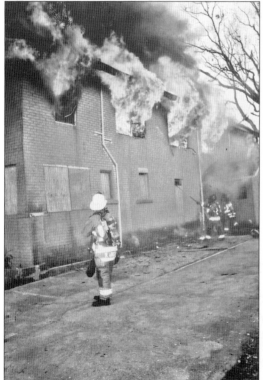

In 2005, firefighters worked against a fire in a two-story apartment complex that was supposed to be unoccupied. However, buildings scheduled for demolition are often attractive lodgings for those who live on the streets, and such habitation often leads to disastrous results. OFD firefighters first perform search-and-rescue tactics to ensure that there are no victims within burning buildings. (Lt. Michael Stallings Jr.)

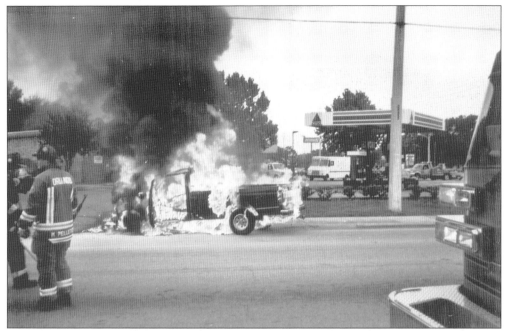

In September of 2005, firefighters arrived at a fully involved pickup-truck fire. While people were not endangered, the vehicle was a total loss. The fire began as a result of repairs that the owner had made on the vehicle without the aid of a professional mechanic. (Firefighter Shawn Keith.)

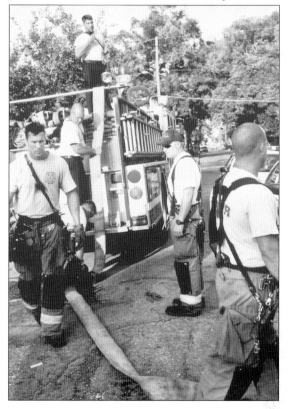

Members of Station Two return to a fire site in 2006 to put out a few hot spots that started to smolder. Clockwise from left, David Giovannini, David Pegues, Neal Yochim, Lt. Danny Wilson, and J. B. Harris start running lines from Tower Two before demolition begins. (Ginger Bryant.)

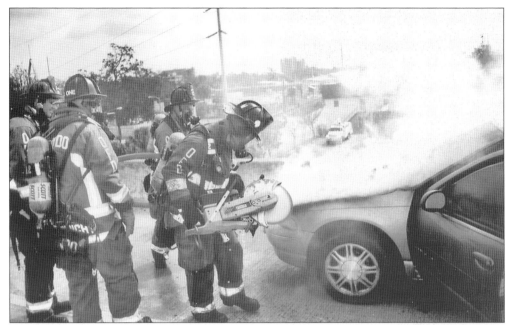

As thick smoke pours from the crevices of a stranded motorist's hood, OFD firefighters use saws in order to gain access to the true source of the flames. Moments after reaching the motor, fire was extinguished before anything explosive took place roadside in 2005. (Lt. Michael Stallings Jr.)

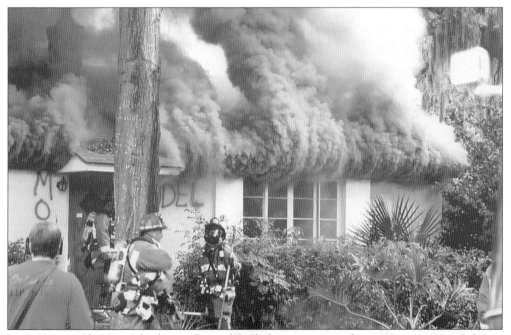

Lt. J. Heaney (forefront) leads members of C Shift in a training fire practice session. A house scheduled for demolition provided firefighters with the real experience of combating a live burn. Part of OFD service includes daily training so that members remain prepared for the unexpected. (Firefighter Shawn Keith.)

With a 24-hour work shift followed by 48 hours off, firefighters' families also make a sacrifice, especially during holidays. Clockwise from left, David Giovannini, Anna Giovannini, Jason Patrick, Gabrielle Giovannini, and Christy Giovannini remain close as a family by occasionally visiting the firehouse after dinner. Gathered in front of Light and Air Truck Two in 2006, the firehouse feels like a second home. (Ginger Bryant.)

While Shawn Keith works on Tower Two, his fellow members of "The Pride," as his firehouse is known, are equally grateful for his skills as a talented cook. With approximately 12 firefighters on any given shift at their station, potatoes have to be mashed in large quantities to feed the troops for dinner, as seen in 2006. (Ginger Bryant.)

In 2005, Lt. Michael Stallings Jr. and other members of OFD decided to begin a Bagpipe and Drum band that would perform at events such as Medal Day, funerals, parades, and other department ceremonies. District Chief Chad Williamson, shown on drums at the 2007 Florida Music Festival, is one of the main participants in the band. (Jim Carchidi.)

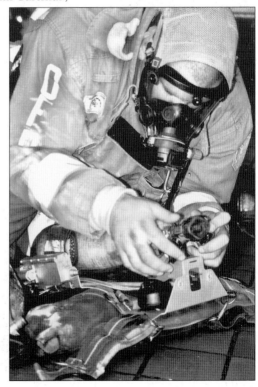

Lt. Michael Stallings, Jr. works with his air pack during a drill in the bays of the firehouse. This 2006 exercise was followed by buddy breathing so that firefighters got the opportunity to practice sharing air in preparation for a shortage of tanks during fire entrapment. (Ginger Bryant.)

Author Ginger Bryant was exposed to the world of firefighting at age four when her grandfather first took her to the Winter Park Fire Department. There she was allowed to sit behind the wheel of an engine during her 1976 tour of the fire station on New York Avenue. (Edmund Clinton Asher.)

During the summer of 2006, Ginger Bryant rode A Shift at Station Two. Though simply posing behind the wheel of Engine Two, she was permitted to observe the men in action on numerous calls. After such an experience, she has the greatest admiration for all of the men at Station Two as well as their brothers in fire around the world. (Lindsey Romaszewski.)